IMAGES
of America

OUTER BANKS SHIPWRECKS
GRAVEYARD OF THE ATLANTIC

IMAGES
of America

OUTER BANKS SHIPWRECKS
GRAVEYARD OF THE ATLANTIC

Mary Ellen Riddle

ARCADIA
PUBLISHING

Published by Arcadia Publishing
Charleston, South Carolina

Printed in the United States of America

Library of Congress Control Number: 2016937469

For all general information, please contact Arcadia Publishing:
Telephone 843-853-2070
Fax 843-853-0044
E-mail sales@arcadiapublishing.com
For customer service and orders:
Toll-Free 1-888-313-2665

Visit us on the Internet at www.arcadiapublishing.com

*To the lifesavers who risked their lives to save shipwrecked
souls, and to those islanders and caring folk who
provided comfort, honor, and sustenance.*

CONTENTS

ACKNOWLEDGMENTS

Great appreciation goes to Joseph K. Schwarzer, executive director of the North Carolina Maritime Museum System, for his support and expert guidance. Special thanks go to Marc Corbett for his knowledge, underwater photographs, dogged vigilance, and constant inspiration. Thanks go to Nathan Richards for his knowledge, expertise, and finesse. Thanks also go to the Graveyard of the Atlantic staff, Clara Scarborough and Bill Francis, for help identifying, locating, and photographing artifacts and to Paul Fontenoy for technical information. A thank-you is extended to all those who donated or located photographs, including Dave Alberg, Lynn Anderson, Daniel Berra, Mike Boring, John Bright, Jim Bunch, Mike Carraway, Tama Creef, Kara Fox, Hal Good, Jami P. Lanier, Philatelie Marine, Stuart Parks, Lori Sanderlin, Will Sassarossi, Dave Sommers, Suzanne Tate, Eve Turek, and Ben Wunderly. Thank you, Allyson Ropp, for piratical information. Appreciation goes to collections personnel across the globe who searched for photographs. Thanks go to researchers before me, such as Gary Gentile, David Stick, and Kevin Duffus, for creating a shipwreck history foundation. Special thanks are extended to Arcadia Publishing and my title manager Liz Gurley, who made a detailed project fun. Finally, appreciation goes to my family, Christopher and Zoe, the Riddle clan, and my dear friends who supported the project through their interest and patience.

INTRODUCTION

Imagine a skeletal vessel lying on the ocean floor. Schools of fish dart about providing contrast to the ship's lifeless form. These remains provide a door into discovery. A comprehensive and methodical examination of shipwrecks can tell us about the vessel's era, people, and places. It can reveal information on piracy, war, and weather and lend insight into a broader cultural landscape of maritime heritage—the history that links the shipwreck to its time. We discover what it was like to live at the edge of a continent, how maritime technology developed, and how people responded to, subsisted on, and, at times, even flourished from shipwrecks.

In the waters off the Outer Banks of North Carolina, from Currituck to Bogue Banks, thousands of shipwrecks rest in the area known as the Graveyard of the Atlantic. Here, epic storms raged around heroic lifesaving events. Warships and merchant ships were ravaged by war. Navigational error caused wrecks and strandings. Whether victims of nature, human error or conflict, or unsolved mystery, shipwrecks provide a perspective on our shared cultural past.

In 1585, the galleass *Tiger*, a participant in Sir Walter Raleigh's Roanoke Voyages, grounded on a shoal in Ocracoke Inlet. Chronicling the event, English explorer Ralph Lane describes a natural threat that long has characterized coastal North Carolina "in y Entry whereof all our Fleet struck agrounde, a y Tyger lyinge beatnge vupon y shoalle for y space of ij houres by the dyalle, wee were all in extreme hasarde of being castawaye, but in y ende by the mere worck of god flottynge of wee ranne her agrounde harde to shoare, and soo with grete spoyelle of our prouysyones, saued our selfes and ye Noble shippe also, with her backe whole, which all they marryners aborde thought coolde not possybelly but hau beene broken in sunder."

Valuable provisions were lost that affected the course of the voyage. For more than four centuries, thousands of ships have met similar or worse fates—hence the region's long-standing, foreboding title. Even today, with all our technological advances, ships and lives are lost off the Outer Banks. Shoals and weather are ever changing; nature continues to play a major role.

North Carolina's barrier islands lie off the mainland and jut into the Atlantic Ocean. These migrating masses and surrounding waters are subject to a variety of conditions. Winds blowing from the northeast or the southwest generate longshore currents that carry sand and deposit it at the capes to create shoals. These shallow-water sandbars extending 30 to 50 meters or more into the Atlantic are difficult to see and chart and are dangerous to navigate. Equally, the region is known for dynamic weather, with storms forming offshore that produce destructive winds and waves. These conditions, combined with the proximity of the Gulf Stream and extension of the Labrador Current—used by mariners as shipping lanes for centuries to avoid doldrums or to gain speed in their journey—create ideal circumstances for abundant shipwrecks. Just like *Tiger*, ships following these currents could find themselves stranded on a shoal or sinking into a raging sea. Vessels perched on shoals bend in ways unnatural to their designs. Wind and waves pounded them, shredding sails, swallowing cargo, splintering ships, and tossing souls into the sea.

Man was as destructive as nature. Pirates targeted the busy shipping routes that passed the North Carolina coast and found secluded hideouts on the nearby islands surrounded by shallow waters. The ever-shifting geography of the coast and inlet required local pilots in light draft vessels to escort larger ships across shoal-infested waters. In fact, piloting was one of the first official jobs available along the coast. Concurrently, these very waterways were perfect for the small, fast piratical sloops, which did not draw as much water as the larger ships their crews plundered and, at times, wrecked.

The Revolutionary War, the War of 1812, the Civil War, and both world wars left their mark on the barrier islands and surrounding waters. Legend has it that bankers lured a British man-of-war ashore and attacked and scuttled it. Mystery surrounds the loss of *Patriot* during the War of 1812. Was its demise an act of war, piracy, or from natural causes? With Hatteras the site of the first amphibious assault in the Civil War, it was not unusual for ship strandings or wrecks to thwart military efforts or even aid them. A vessel could purposely be sunk to act as a blockade or set on fire to stop it from being used.

During World Wars I and II, U-boats attacked Allied ships off the Outer Banks. Approximately 90 Allied vessels and four U-boats were sunk. Although largely unknown to the rest of the country, the war was experienced firsthand by Outer Banks residents. They put forth valiant lifesaving efforts and witnessed fiery explosions of ships at sea that caused their houses to shake and covered beaches with oil and shipwreck debris. Locals observed blackouts, and their once peaceful islands were transformed into a war zone dubbed "Torpedo Junction."

The need for professional lifesaving facilities and trained lifesavers grew out of what once was a caring yet untrained response to human suffering. The 1870s marked the creation of the US Life-Saving Service. Surfmen from stations along the coast patrolled the shores and, when possible, rescued sailors and passengers from doomed ships. These actions were arduous and demanded continual training and vigilance, often putting surfmen's lives in jeopardy. Not all efforts were successful due to seasonal operation hours, lack of stations, and questionable hirings and practices. Catastrophic loss of life led to investigations, expansion of the service, and the placement of additional stations along the coast, as well as historic appointments of personnel.

Outer Banks families were also involved in lifesaving efforts, caring for those in shock or rescued safely, nursing those found half dead and naked on the shore, or burying the dead with reverence in the dunes. Records show that a women's relief society in the northeastern part of the country sent clothing and supplies to support the effort. Local lore recounts stranded sailors becoming part of village communities with modern-day Bankers claiming ancestry to shipwrecked mariners. The surfmen who performed the amazing rescues are still honored today as a central part of Outer Banks history. They are the heroes, the link from ship to shore, that risked all as a daily part of coastal living.

Shipwrecks of the Outer Banks moves through time introducing memorable folk and communities and provides views of relics—some submerged for centuries—from a naturally amazing place. Emphasizing the power and nature of humankind, it presents a sense of the maritime culture of the North Carolina Outer Banks.

Ships discussed in *Shipwrecks of the Outer Banks* appear in alphabetical order, affording a guidebook simplicity enabling the reader and researcher alike to easily reference the more than 100 shipwrecks included in the book. To gain an understanding of the science and geography of the Outer Banks and to locate the areas where specific ships sank, examine the map and graphic on pages 9 and 10. Begin your journey of discovery by imagining a sea laden with skeletons that have stories to tell.

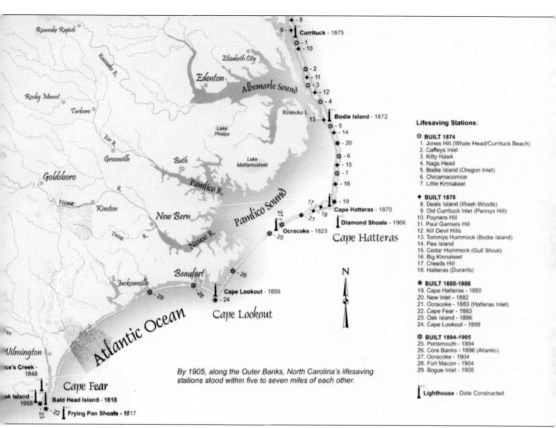

By 1905, along the Outer Banks, North Carolina's lifesaving stations stood within five to seven miles of each other.

This is a map of the Graveyard of the Atlantic that stretches from Currituck to Bogue Banks. It includes the location of the US Life-Saving Stations that operated along the coast, providing aid to shipwrecks that occurred in this area. (Courtesy of *The Way We Lived in North Carolina*, edited by Joe A. Mobley. Maps by Mark Anderson Moore. Copyright © 2003 by the University of North Carolina Press. Published in association with the North Carolina Department of Cultural Resources, Office of Archives and History. Used by permission of the publisher. www.uncpress. unc.edu.)

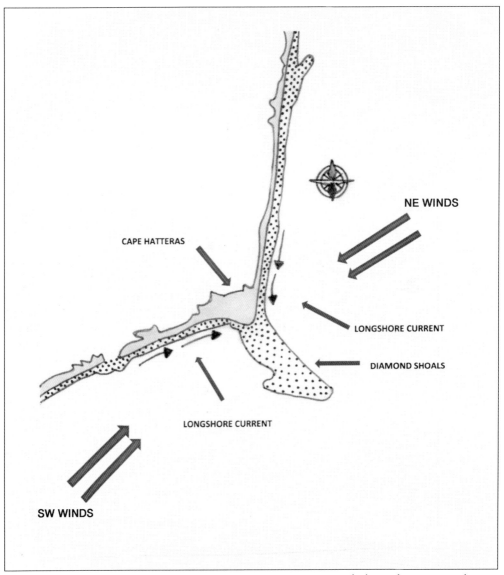

This illustration demonstrates how longshore currents carry sand along the coast to deposit it at Cape Hatteras to form the treacherous Diamond Shoals. (Courtesy of Graveyard of the Atlantic Museum.)

One

A.B. GOODMAN TO ESSO NASHVILLE

It was April 4, 1881, and snow, mixed with a raging wind, set the scene for the wreck of the schooner *A.B. Goodman*. It grounded on Diamond Shoals with four men clinging to its rigging. Rescuers from Creeds Hill Life-Saving Station set out in a surfboat fighting opposing current and strong wind. Anchored near *A.B. Goodman*, the lifesavers waited several hours until they could make a move. Their lifeboat took on water as they watched the ship begin to break apart. Just when the wind abated, they began coaxing the terrified survivors into the small vessel. One man already had washed overboard and drowned. It took hours to row the heavily laden surfboat to shore where the men received sustenance. This illustration by J.H. Merryman, *Ship at Sea*, aptly illustrates the drama faced by shipwrecked crews. (From *United States Life-Saving Service – 1880* by J.H. Merryman.)

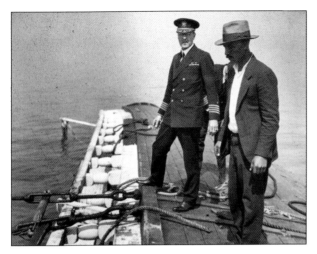

Several sources cite the date of the sinking of *A. Ernest Mills* (pictured here) as May 3, 1929. Yet period newspaper accounts of the sinking came out in April 1929. The Friday, April 5, 1929, *Index-Journal* of Greenwood, South Carolina, reports missing on Wednesday of that week the schooner's captain, A.C. Chaney of East Kingham, New Hampshire, and crew members George Barnes of Portsmouth, Virginia, and Paul Ferguson of Norfolk, Virginia. (Courtesy of The Mariners' Museum, Newport News, Virginia.)

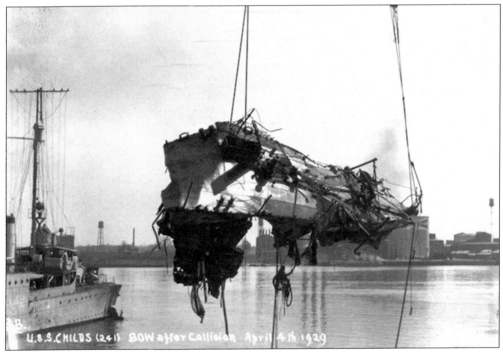

Apparently, the schooner *A. Ernest Mills* sank following a collision off Currituck with the destroyer *Childs* (pictured here). The American four-masted ship surfaced after her cargo of salt dissolved. It was towed by salvagers to Currituck Beach. The front compartment of the destroyer was wrecked. Rescued by sailors from *Childs* were George Carver, first mate; Albert Raymond; Edward Williams; Percival Hendricks; James Smith; and William Franklin. (Courtesy of Gene Kreeft, NavSource.)

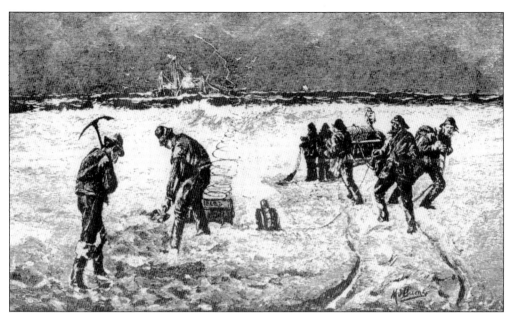

Aaron Reppard wrecked on August 16, 1899, during the San Ciriaco hurricane. She grounded in the surf about 13 miles north of Big Kinnakeet Life-Saving Station while carrying a cargo of coal. The eight-man crew climbed into the rigging. Lifesavers from Chicamacomico, Gull Shoal, and Little Kinnakeet Life-Saving Stations gathered on the beach. They attempted to fire shots to reach the vessel while watching a spectacle unfold. This illustration depicts lifesaving efforts. (From *United States Life-Saving Service – 1880* by J.H. Merryman.)

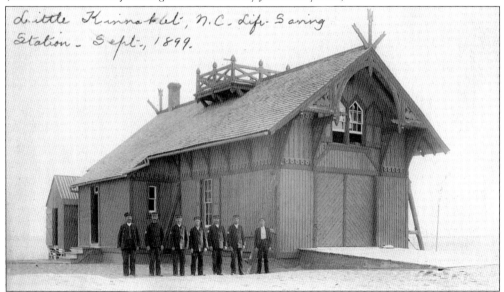

The storm wrenched one man from *Aaron Reppard*'s mizzenmast. His leg caught in a rope, and he was battered against the mast. As the ship disassembled, another man died. Capt. Osker Wessel jumped into the sea in an attempt to reach the beach then doubled back and drowned. The foremast collapsed, and the remaining men fell into the breakers. Three men survived. This image shows the lifesavers from Little Kinnakeet Life-Saving Station. (Courtesy of Outer Banks History Center.)

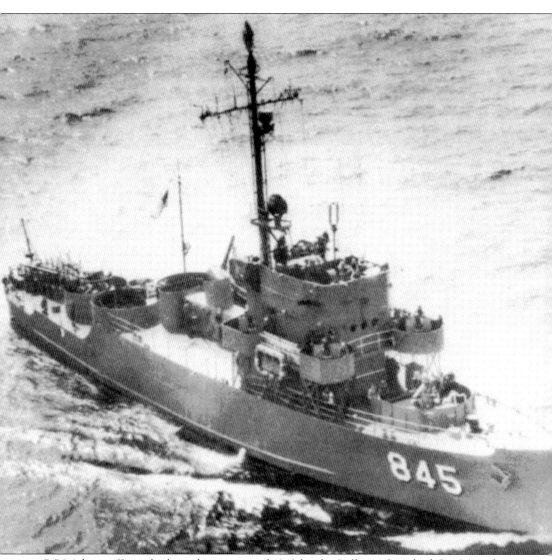

R/V *Advance II* was built in the summer of 1943 by the Pullman Standard Car Manufacturing Company of Chicago, Illinois. The 746-ton motor vessel, called *PCE-845* (Patrol Craft Escort) at the time, was commissioned by the Navy in 1944 and escorted convoys from Port of Spain, Trinidad, to Brazilian ports. She did training operations stateside and conducted antisubmarine patrols and escort missions in the Philippines. Her duty included patrolling the Leyte Gulf. *PCE-845* worked weather patrols and air-sea rescues. Following her decommissioning in 1964, the vessel was purchased by Cape Fear Technical Institute of Wilmington, North Carolina, and named R/V *Advance II* in memory of *Advance*, a Confederate blockade-runner. R/V *Advance II* was then donated to the North Carolina Department of Fisheries. In 1994, she was placed off Kitty Hawk as an artificial reef. She is an active training and certification site for divers. (Courtesy of US Navy.)

Aleta stranded on Ocracoke Island during the Great Atlantic hurricane of September 1944. Built in 1923, she operated as a mail boat between Morehead City and Ocracoke. *Aleta* traveled the coastal waters delivering letters, packages, groceries, and people. Passengers passed time fishing the sound waters. It was a social event to meet *Aleta* at the docks. People gathered to chat, pick up mail, and greet visitors. (Courtesy of Ocracoke Preservation Society.)

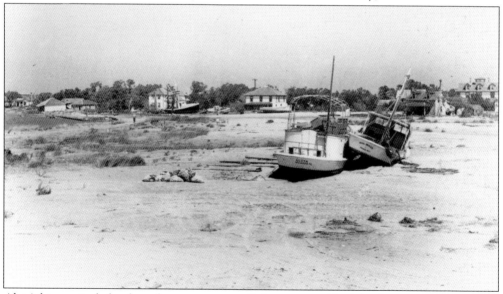

Aleta's history includes that of a rumrunner until she was seized by federal agents and auctioned. The 42-foot vessel eventually was converted to a shrimp boat. About 50 people were killed in the storm along the Outer Banks that stranded *Aleta* high and dry. (Courtesy of National Park Service, Cape Hatteras.)

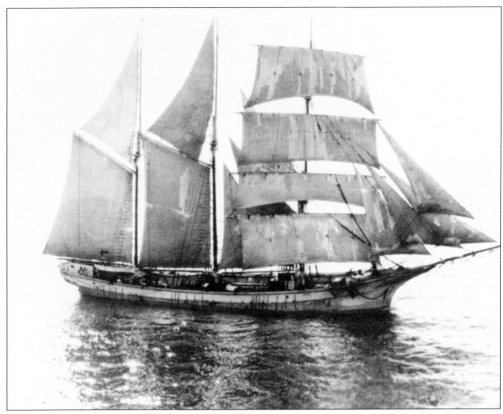

Barkentine *Altoona* wrecked on October 22, 1878, in a hurricane that originated in the tropics. The storm was reported in the *Brooklyn Daily Eagle* to be central over Cape Hatteras "with greatly increased velocity." (Courtesy of National Park Service, Cape Hatteras.)

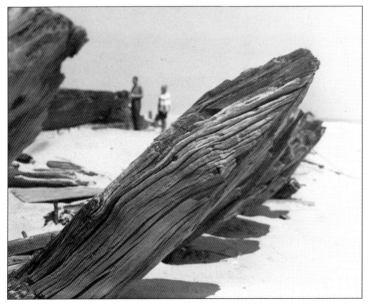

Registering 60-mile-per-hour winds, the storm wrecked multiple vessels, including the two-masted *Altoona* that went ashore loaded with logwood. According to the October 25, 1878, *Atlanta Constitution*, she was a total loss with the "deck load washed off." All were saved. (Courtesy of National Park Service, Cape Hatteras.)

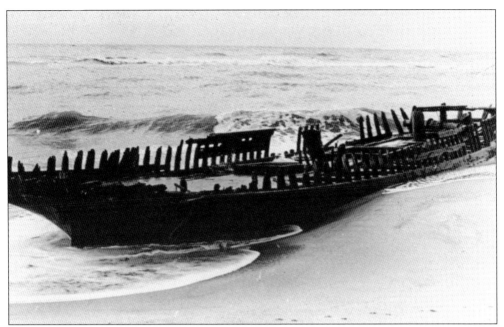

Altoona's bow was smashed and her head gear damaged. The steamer *Chas. W. Lord*, which grounded off Frying Pan Shoals while carrying tobacco, sugar, and molasses, was caught in the same storm, along with *General Barnes* and the iron steamship *City of Houston*. (Courtesy of National Park Service, Cape Hatteras.)

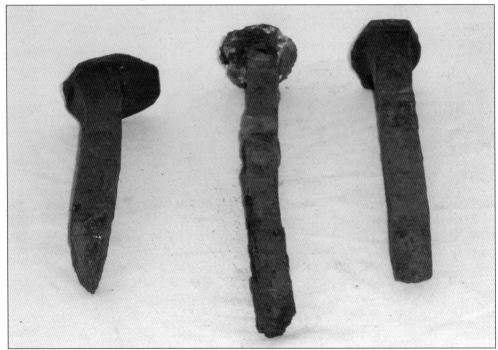

Altoona was uncovered in 1963. Her remains are visible north of the pond at Cape Point in Buxton, but a shipwreck historian notes the area is "snake infested." Pictured here are three spikes from *Altoona*. (Courtesy of Graveyard of the Atlantic Museum.)

Andrew Johnson was a side-wheel steamer that operated most of her career as USS *State of Georgia*. She was built in 1851 by Vaughn & Lynn of Philadelphia, Pennsylvania, and was bought by the Union navy from the Philadelphia and Savannah Steamship Co. as a blockade support gunship. USS *State of Georgia* was commissioned at the Philadelphia Navy Yard on November 20, 1861, and captained by Comdr. James F. Armstrong. The 1,204-ton ship participated in a number of assignments, including the capture of the blockade-runner *Constitution* off Wilmington, North Carolina, and *Nassau* near Fort Casswell, North Carolina. She was decommissioned in the fall of 1865 and publicly auctioned. USS *State of Georgia* was renamed *Andrew Johnson*. Less than five months later, *Andrew Johnson* ran aground during a hurricane off the coast at Currituck Inlet. The ship was a total loss. The paddle wheel crank arm seen here is believed to be from *Andrew Johnson*. (Courtesy of Marc Corbett.)

Anna R. Heidritter, built in Bath, Maine, was one of the last grand sailing ships to wreck off the Outer Banks. In March 1942, while U-boats were patrolling the waters off the coast of North Carolina, she was about four days at sea when she met her fate. (Courtesy of National Park Service, Cape Hatteras.)

Prior to running aground off the Outer Banks in a nor'easter, the vessel had seen plenty of troubles. As the former *Cohassett*, *Anna R. Heidritter* caught fire six years before her demise. The lumber transporter saw World War II action, having had her mast taken off by U-boat fire while on a trip to the Mediterranean. (Courtesy of National Park Service, Cape Hatteras.)

On May 2, 1942, *Anna R. Heidritter* took refuge from a nor'easter near Hatteras Inlet. While awaiting passage of the storm, the four-masted schooner was pummeled by wind and wave, and her anchor chains pulled free. The sailing ship was pushed by gale-force winds onto the shore of Ocracoke Island. The crew of eight was tied to the mast. (Courtesy of National Park Service, Cape Hatteras.)

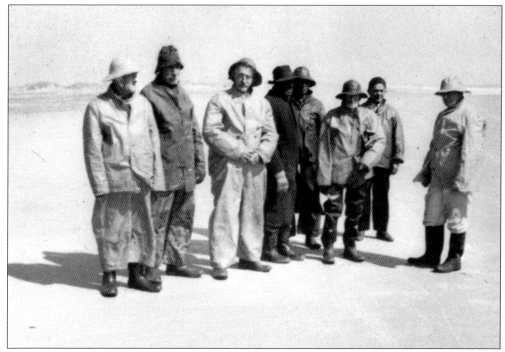

Coast Guardsmen from the Hatteras Inlet Life-Saving Station came to *Anna R. Heidritter*'s rescue. Capt. Bennett D. Coleman and her crew were saved. The crew is shown in this photograph. (Courtesy of Cape Hatteras National Park Service, Cape Hatteras.)

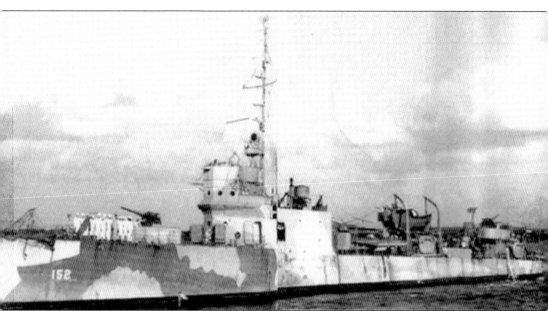

On March 15, 1942, tanker SS *Ario* was traveling in ballast, unarmed, and in a blacked-out state when she was torpedoed by *U-158*. Built in 1920 by Bethlehem Ship Building Corp. of Sparrows Point, Maryland, the 6,952-ton ship was sailing from New York to Corpus Christi and southwest of the Cape Lookout Light Buoy when the torpedo hit her on the starboard side. Eight crew members were killed and 28 survived. USS *Du Pont* picked up survivors. When the ship's officers boarded *Ario* to assess damages, they found her to be a total loss. She sank east of Cape Lookout. *U-158* met her end on her next patrol west of Bermuda. She was sunk by depth chargers from a Navy PBM Mariner aircraft. The crew of 54 did not survive. Before her demise, *U-158* damaged two ships and sank 17 others. Pictured here is USS *Du Pont*. (Courtesy of US Navy.)

On December 24, 1899, steamship *Ariosto* grounded in the breakers about three miles south of Hatteras Inlet. The 2,920-ton vessel was bound for Hamburg, Germany, carrying cottonseed, lumber, cotton, and wheat valued at more than $1.5 million. Despite receiving answer to his signal, Capt. R.R. Baines went against US Life-Saving Service rules to stay with the ship until help arrived if driven onshore near a station. This is the service's seal. (Public domain.)

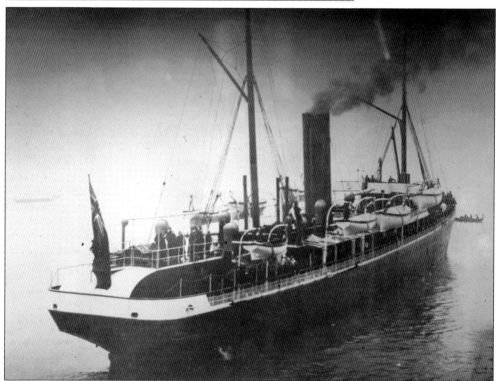

A lifeboat and pinnace were filled with men and cast loose before lifesavers reached them. Five men, including the captain, stayed on *Ariosto*. The two vessels capsized in the heavy seas. Two men swam back to the ship. Several others were dragged from the surf by lifesavers. The captain and men on board were rescued, but 21 victims were buried on Ocracoke Island. (Courtesy of The Mariners' Museum, Newport News, Virginia.)

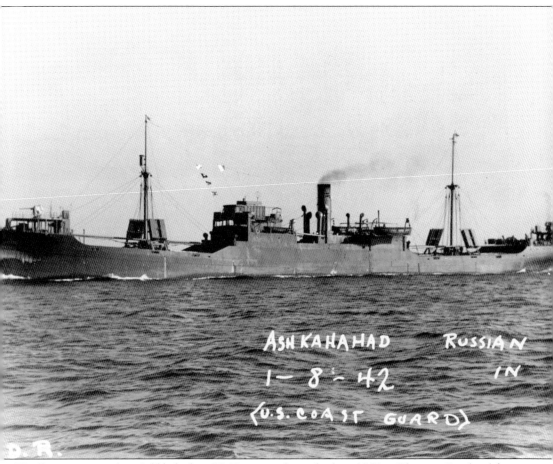

ASHKAHAHAD RUSSIAN
1 — 8 — 42 IN
(U.S. COAST GUARD)

D.R.

The Russian cargo ship *Ashkhabad*, a 402 Type vessel, was built in 1917 in Glasgow, Scotland, by Harland & Wolff Ltd. The 5,284-ton ship sits today at the bottom of the sea off Cape Lookout. She was torpedoed by *U-402* on April 29, 1942, and later shelled by Allied forces after being perceived a navigational hazard. The shelling was done in error. *Ashkhabad*, traveling from New York to Cuba, was scheduled to be salvaged by the tug *Relief*. But before the salvage ship could arrive at her destination, USS *Semmes* DD-189 and HMS *St. Zeno* shelled her. All crewmen were rescued following the torpedo action and taken to Morehead City, North Carolina, by the AWS trawler *Lady Elsa*, which had been escorting *Ashkhabad* on her journey. (Courtesy of The Mariners' Museum, Newport News, Virginia.)

In mid-March 1942, *Australia* was traveling through U-boat–patrolled waters on her way to deliver 110,000 barrels of oil from Port Arthur, Texas, to New Haven, Connecticut. Multiple ships were torpedoed in the area the day before. Capt. Martin Ader followed the coast, traveling close to Ocracoke Inlet. Shown here are heating exchangers from *Australia*. (Courtesy of Marc Corbett.)

Australia zigzagged through fog around Diamond Shoals before becoming the target of *U-332*. She blew a hole in *Australia*'s starboard side, killing four people. The Coast Guard received the SOS. The ship was abandoned. The 36 men were picked up from their lifeboats by *William J. Salman*. Shown here is one of *Australia*'s winches. (Courtesy of Marc Corbett.)

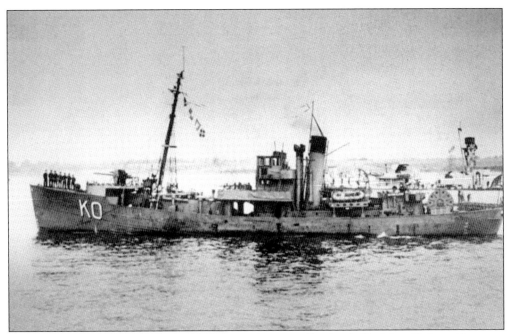

HMT *Bedfordshire* was a commercial fishing trawler owned by the Bedfordshire Fishing Company before being acquired by the Royal Navy in August 1939. She was converted to a naval trawler to perform antisubmarine duty and do patrols and escort duty off the southwest coast of England and in the Bristol Channel. In March 1942, she was sent to the United States to assist with antisubmarine duty along the East Coast. (Courtesy of Gary Gentile.)

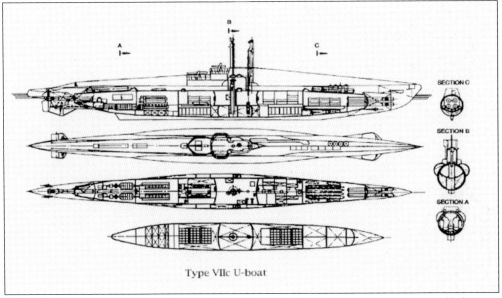

Type VIIc U-boat

HMT *Bedfordshire*, commanded by Lt. Russell Bransby Davis, RNR, primarily patrolled Outer Banks waters where U-boats were hunting enemy vessels. In May 1942, she arrived in Hatteras to search for a U-boat in the vicinity of Ocracoke Island. In the early morning of May 12, *U-558* fired two torpedoes at HMT *Bedfordshire* and missed. This illustration depicts the design of *U-558*, a VIIc U-boat. (Public domain.)

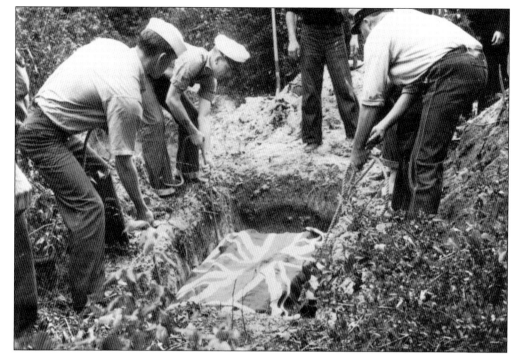

A third shot sank HMT *Bedfordshire* with 37 men on board. All died. A few days later, two bodies were found on Ocracoke Island wearing British uniforms. They were identified as Sub Lt. Thomas Cunningham and Ordinary Telegraphist Stanley Craig of HMT *Bedfordshire*. They were buried on Ocracoke Island (pictured here). Two unidentified bodies were found floating in the sea and were buried in the same plot. (Courtesy of National Park Service, Cape Hatteras.)

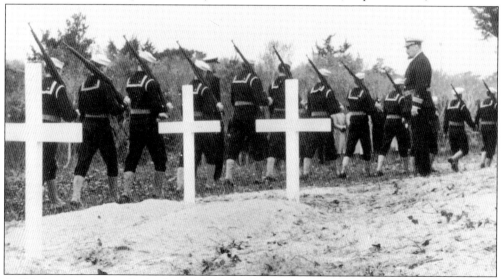

A fifth British sailor washed ashore near Swan Quarter and a sixth on Hatteras Island; he was buried in Buxton where a victim from the merchant ship *San Delfino* had been buried a month earlier. Both island cemeteries hold ceremonies every May honoring the British war dead. The Buxton cemetery is pictured here. The wreck is protected as a war grave under the Protection of Military Remains Act of 1986. (Courtesy of National Park Service, Cape Hatteras.)

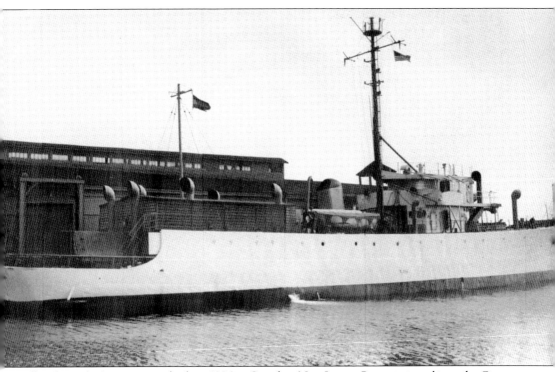

Bedloe, formerly *Antietam*, was built in 1926 in Camden, New Jersey. Commissioned into the Coast Guard in 1927, she combatted bootleggers and smugglers off the East Coast. *Antietam* segued into search and rescue and maritime law enforcement before coming under the command of the US Navy at the outbreak of World War II. Outfitted for war, *Antietam* was assigned to convoy escorts and to patrol shipping waters. Renamed *Bedloe*, she joined her sister-ship, *Jackson*, to escort the Liberty ship SS *George Ade*, which had been torpedoed on September 12, 1944. *George Ade* was being towed by the tug USS *Escort* off Cape Hatteras. A hurricane was thwarting progress. The towline parted twice. Visibility became difficult. *Bedloe* and *Jackson* lost site of the ships. Hurricane seas damaged *Bedloe*'s depth charge racks and stern fittings. She was struck by multiple waves and capsized. The crew abandoned the boat, but 26 men did not survive the 51 hours clinging to life rafts before rescue arrived. *Jackson* met a similar fate as *Bedloe*. (Courtesy of The Mariners' Museum, Newport News, Virginia.)

On November 29, 1909, bound from Port Antonio, Jamaica, to New York, the German steamship *Brewster* was loaded with fruit when she arrived off the Hatteras Island coast. *Brewster* grounded on Diamond Shoals. Lifesavers responded from Cape Hatteras, Big Kinnakeet, Creeds Hill, and Hatteras Inlet Life-Saving Stations, but powerful seas thwarted their efforts. One boat was disabled. A power lifeboat was towed to the ship by a fishing powerboat. Pictured here is the Hatteras Inlet Station. (Courtesy of Ocracoke Preservation Society.)

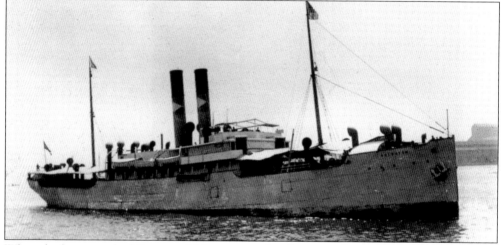

When the boats reached *Brewster*, high seas were breaking over her. Lifesavers put out a buoy with a rope attached, and the current floated it to the fishing vessel. The men were hauled by the rope into the lifeboat and transferred to the powerboat. The lifesavers earned multiple gold and silver lifesaving medals. The beach was covered with fruit for days. (Courtesy of Uhle Collection, Steamship Historical Society Archives.)

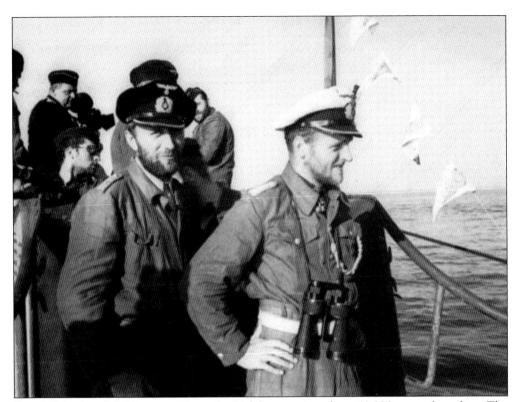

British Splendour left Houston, Texas, for Halifax carrying about 10,000 tons of gasoline. The tanker was running with lights out, armed, guarded, and under escort. It was April 7, 1942, and the ship, under command of Capt. John Hall, was traveling near Diamond Shoals. About two miles north of Diamond Shoals Buoy, a torpedo hit the port side of the English tanker. *U-552*, under command of the infamous Eric Topp (pictured here, right), was responsible for the hit. Three lifeboats and a raft were launched from the tanker. The 41 survivors were rescued by their escort, the British armed trawler HMS *St. Zeno*. Twelve crewmen were killed in the attack. The 7,138-ton ship, built by Palmers' Company, Ltd. of Newcastle, England, capsized and lies in about 100 feet of water. (Courtesy of Bundesarchiv, Bild I01II-MW-3676-28/Buchheim, Lothar-Günther/ CC-BY-SA 3.0.)

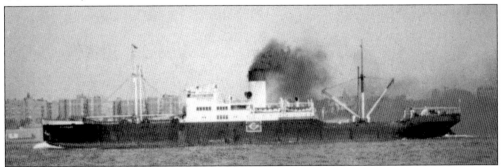

The Brazilian passenger freighter *Buarque* was lost in Torpedo Junction during February 1942. Carrying 85 people, she was traveling from Curaçao to New York flying a Brazilian flag. Protected under neutrality laws, *Buarque* ran northeast of Kill Devil Hills with her lights on through U-boat–infested waters. On February 15, *U-432* launched a torpedo that tore into *Buarque*'s port side. Crew and passengers took to lifeboats. (Courtesy of Gary Gentile.)

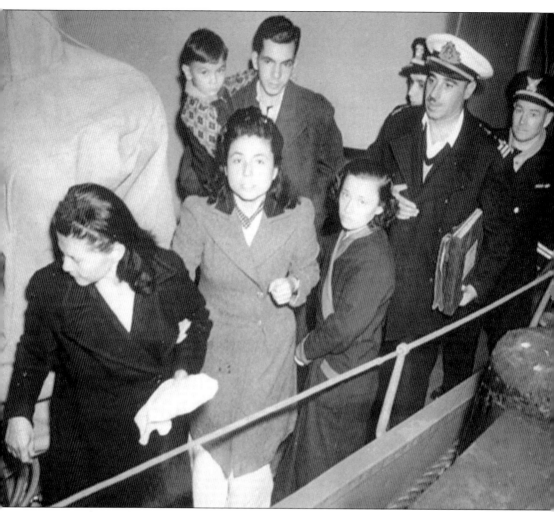

A second torpedo ripped into *Buarque*, causing waves to nearly swamp survivors. The freighter sank. On the following evening, two lifeboats were spotted by air and rescued by the Coast Guard cutter *Calypso*. A third lifeboat was discovered the next morning, and after at least 60 hours at sea, the final lifeboat passengers were rescued by the US destroyer *Jacob Jones*. Pictured here are survivors from *Buarque*. (Courtesy of Gary Gentile.)

Between poor weather, shallow water, war, and human error, the obstructions to smooth navigation off the North Carolina Outer Banks are many. On August 15, 1979, making what is called a shakedown cruise to check "freezers and other equipment while at sea," the steel-hulled trawler *Capt. Malc* ran into trouble. Christened the preceding April, the infant squid boat was making her maiden voyage when she went aground in 9.25 feet of water. The Coast Guard lent assistance to the vessel, which was pinned against wooden fenders that lined the channel below the Herbert C. Bonner Bridge at Oregon Inlet. A 44-foot Coast Guard cutter was able to "pull the vessel free at slack tide." *Capt. Malc* was able to make her way back to the Wanchese docks. Quoted material is from J. Foster Scott, in an August 15, 1979, article for the Dare County Tourist Bureau. (Courtesy of Outer Banks History Center.)

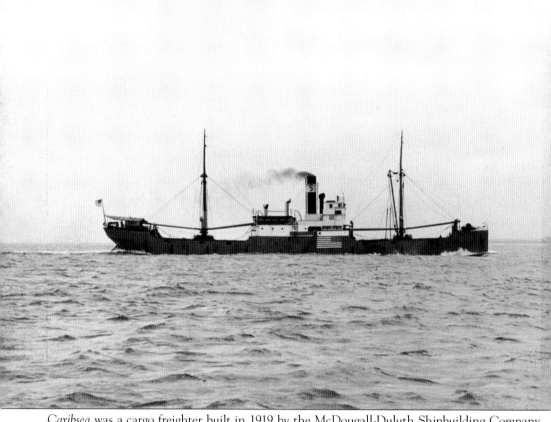

Caribsea was a cargo freighter built in 1919 by the McDougall-Duluth Shipbuilding Company of Duluth, Minnesota. The 2,609-ton ship was torpedoed by *U-158* on March 11, 1942, off Cape Lookout. She was hit by torpedo fire and is said to have sunk in less than three minutes. The ship was carrying a valuable load of manganese ore. As the crew of *Caribsea* was unable to launch the lifeboats, they jumped into the sea. Only a quarter of the 28-member crew managed to cling to the wreckage for the 10 hours it took for the freighter SS *Norlindo* to pick them up. One of *Caribsea*'s officers, engineer James Baugham Gaskill, was killed when the ship sank. He was born on Ocracoke Island. The glass case that contained his license and those of the other officers drifted ashore at Ocracoke Island. (Courtesy of The Mariners' Museum, Newport News, Virginia.)

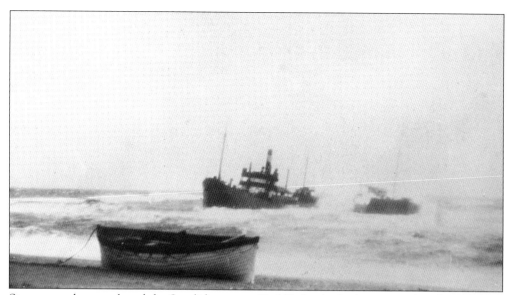

Stormy weather enveloped the Swedish steamer *Carl Gerhard*, which was traveling from Mabou, Nova Scotia, to Tampa, Florida. The 1,504-ton tanker was carrying 2,000 tons of plaster rock. Visibility was poor, and the captain believed he was "at least 50 miles at sea." In late September 1929, *Carl Gerhard* grounded on the outer bar off Kill Devil Hills and struck the hull of the sunken Greek tanker *Kyzikes*. (Courtesy of NOAA Monitor National Marine Sanctuary.)

Carl Gerhard was breaking apart. Crews from Bodie Island Life-Saving Station and three other stations came to the rescue. Lifeboats were useless in the crashing seas. Surfmen, guided by keeper Herman Smith, set up the Lyle gun and sent out a shot. From early dawn to the afternoon, they brought to shore the people on board, as well as two dogs and a cat. Pictured is an underwater section of *Carl Gerhard*. (Courtesy of Jim Bunch.)

Formerly a small cruiser known as SMS *Geier* of the German Imperial Navy, USS *Carl Schurz* was seized by the US Navy in April 1917 when hostilities between Germany and the United States began. She was commissioned as a patrol gunboat and placed in convoy duty. Shown here are speaking tubes from *Carl Schurz*. (Courtesy of Graveyard of the Atlantic Museum.)

Carl Schurz was assigned to the American Patrol Detachment and deported to Charleston. She performed towing missions and did escort duty, as well as conducted patrols along the East Coast and in the Caribbean. Pictured here is a sextant from *Carl Schurz*. (Courtesy of Graveyard of the Atlantic Museum.)

On June 19, 1918, *Carl Schurz* left New York for Key West. On June 21, while southwest of the Cape Lookout Lightship, she was hit by SS *Florida*, which was running without lights due to wartime conditions. One crewman was killed and 12 others were injured in the wreck that destroyed the starboard side of the bridge. Pictured here is a binnacle from *Carl Schurz*. (Courtesy of Graveyard of the Atlantic Museum.)

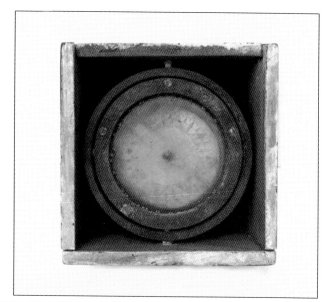

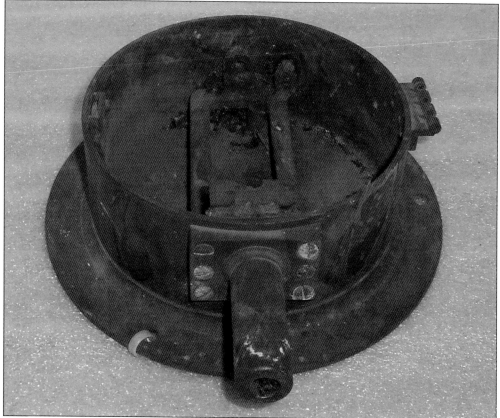

Carl Schurz sank three hours after impact off Beaufort Inlet. The ship weighed 1,603 tons and was propelled by a coal-fired steam engine. She sits in 115 feet of water and is protected by sovereign immunity. Pictured here is a revolution counter gauge from *Carl Schurz*. (Courtesy of Graveyard of the Atlantic Museum.)

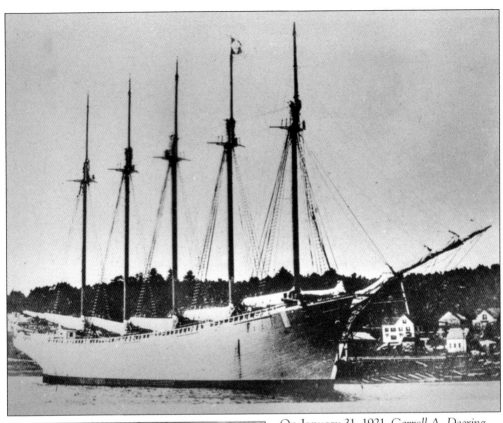

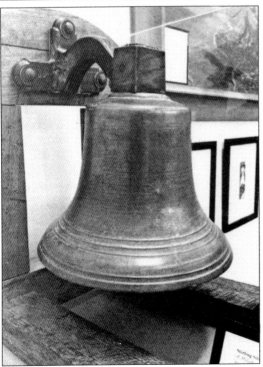

On January 31, 1921, *Carroll A. Deering*, a five-masted schooner, grounded on Diamond Shoals. She first launched in 1919 in Bath, Maine, for the G.G. Deering Company. The 2,114-ton vessel was commanded by Capt. W.T. Wormell. Traveling in ballast, she was spotted on the shoals with "all sails set" by surfman C.P. Brady of the Cape Hatteras Coast Guard Station. (Courtesy of National Park Service, Cape Hatteras.)

Carroll A. Deering eventually washed ashore but not before lifesavers from Hatteras Inlet, Creeds Hill, Cape Hatteras, and Big Kinnakeet Life-Saving Stations attempted to reach her. They came within a quarter of a mile but were unable to see her name or signs of life. The lifeboats were missing from the ship. Lifesavers assumed her abandoned. Pictured is a bell from *Carroll A. Deering*. (Courtesy of Graveyard of the Atlantic Museum.)

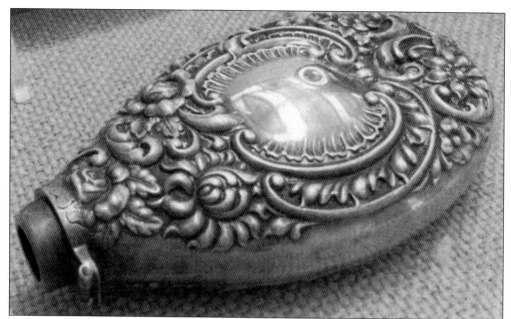

It took four days for the seas to calm down enough to board *Carroll A. Deering*. When reached on February 4, her seams were split apart and her hull full of water. Food was on the stove. Charts were scattered about. Wreckers took off what they could remove. She eventually was dynamited. Shown here is a silver flask believed to have come from the ship. (Courtesy of Graveyard of the Atlantic Museum.)

Much speculation surrounds the mystery of *Carroll A. Deering*, including abandonment, piracy, and mutiny. Her wreckage floated up onto a beach near Hatteras. The schooner's capstan, visible in this photograph, is part of the Graveyard of the Atlantic Museum's collection. (Courtesy of Graveyard of the Atlantic Museum.)

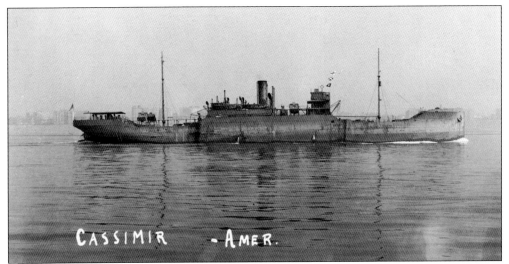

CASSIMIR -AMER.

Cassimer was built in 1920 by the American International Shipbuilding Corporation. Homeport for the 5,030-ton tanker was Baltimore, Maryland. She was to be used for shipping during World War I but was not finished in time and was sold and converted to a general cargo ship. On the night of February 26, 1942, *Cassimer* was traveling in the vicinity of Frying Pan Shoals carrying a load of molasses. (Courtesy of The Mariners' Museum, Newport News, Virginia)

It was a foggy night, and *Cassimer* was running full speed due to reports of U-boats in the area. She was struck by the bow of SS *Lara*. Five crew members were killed in the collision. *Cassimer* was abandoned. Lifeboats and a raft were launched. The remaining 32 crew members were rescued by SS *Lara*. *Cassimer* sank near Cape Lookout. Pictured here are parts from *Cassimer's* wall-mounted engine telegraph. (Courtesy of Graveyard of the Atlantic Museum.)

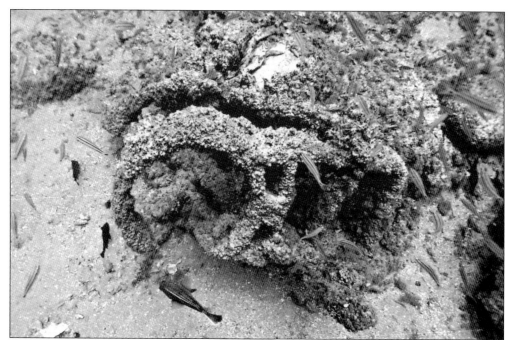

Catherine M. Monahan was a wooden four-masted schooner weighing 986 tons. The oak beauty was built in 1904 in Mystic, Connecticut, by M.B. McDonald. On August 24, 1910, while traveling from New York to Knight's Key, she struck bottom off Cape Hatteras while crossing Diamond Shoals. The impact was enough to create a leaking hull and cause the vessel to sink. Shown here is one of the ship's mast steps. (Courtesy of Marc Corbett.)

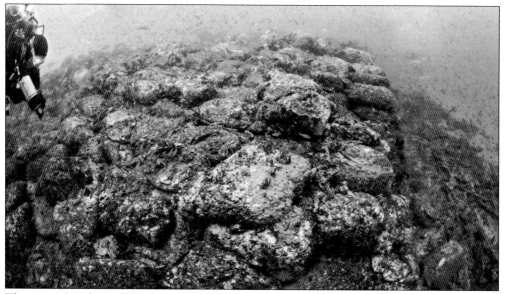

The crew of *Catherine M. Monahan* was rescued, and a letter of praise was sent to Durant's Life-Saving Station for the surfmen's efforts. The revenue cutter *Seminole* was sent to destroy her as she was seen as a danger to navigation. *Catherine M. Monahan* was carrying a load of cement, which, when coming in contact with water, solidified. Pictured here are the remains of the cement. (Courtesy of Hal Good.)

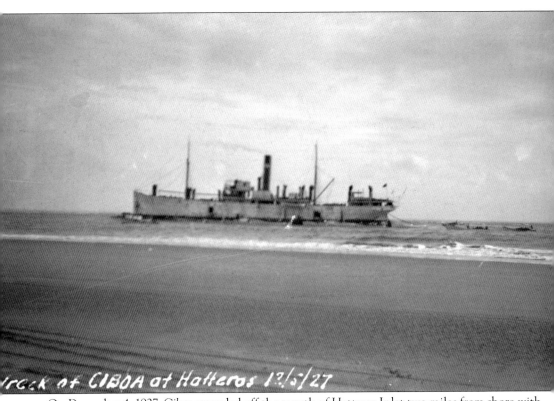

rc.k at CIBOA at Hatteros 12/5/27

On December 4, 1927, *Cibao* stranded off the mouth of Hatteras Inlet two miles from shore with crashing breakers thwarting rescue attempts. Approximately 17,000 bunches of Jamaican bananas were on board and eventually provided islanders with foodstuffs galore. Lifesavers attempted to reach the vessel via powerboat but were unsuccessful and returned to shore for their smaller lifeboat. On hand were the keeper and crew from Ocracoke Life-Saving Station and keepers from Cape Hatteras, Creeds Hill, and Durant stations. They towed the surfboat through the inlet and let her lose near *Cibao*, but the water was so rough, they were unable to get close to the ship. *Cibao*'s crew was instructed to don lifebelts and to tie a line about their bodies and jump into the sea. The surfboat dragged each crewman to calmer water and pulled him aboard. Once the boat was filled, the crew was transferred to the larger powerboat. The 24-member crew was brought to safety, and *Cibao* was refloated. (Courtesy of The Mariners' Museum, Newport News, Virginia.)

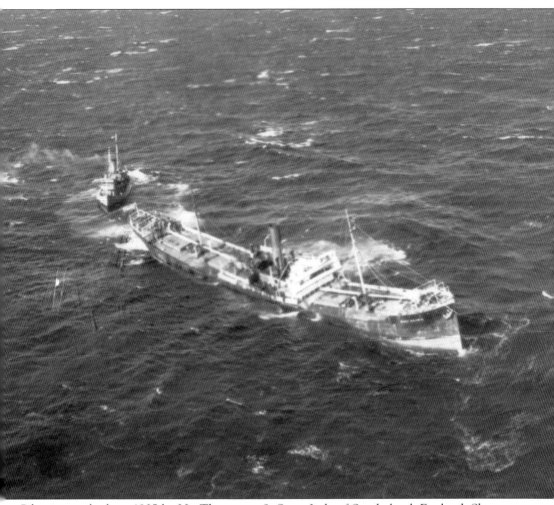

Ciltvaira was built in 1905 by J.L. Thompson & Sons, Ltd., of Sunderland, England. She was traveling with a cargo of paper from Norfolk to Savannah through U-boat territory under Capt. Skarlis Kerbergs. In late January 1942, the 3,779-ton tanker was torpedoed by *U-123* off Gull Shoal. The *Valley Morning Star* in Harlingen, Texas, reported the Latvian vessel was hit amidships and abandoned in a "flooded and sinking condition." The captain did order the ship abandoned, and lifeboats were launched. Kerbergs and some of the crew reboarded the ship and an attempt was made to tow the damaged vessel. The attempt failed. An American tanker, *Socony Vacuum*, brought 21 members of the crew ashore at Charleston, South Carolina, and nine officers and crewmen came ashore via SS *Bury* of Brazil. Two men died. (Courtesy of Gary Gentile.)

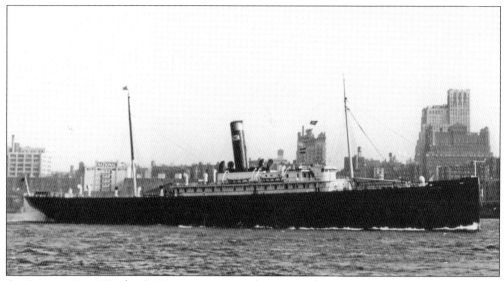

On January 19, 1942, the 5,269-ton cargo vessel *City of Atlanta* was torpedoed by *U-123* near Wimble Shoals. The submarine rose to the surface and lit the waters with a searchlight "while the crew of the ship sought to keep it afloat." (Courtesy of Steamship Historical Society Archives.)

Two men were found clinging to wreckage of *City of Atlanta* about 12 miles from the wreck site. Less than a handful of the 46-member crew survived. Pictured here is a bilge pump from *City of Atlanta*. (Courtesy of Graveyard of the Atlantic Museum.)

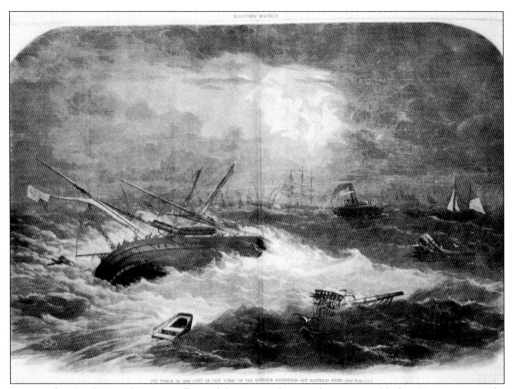

During the Civil War, the Union fleet of the Burnside Expedition assembled in Hampton Roads, Virginia, destined for Roanoke Island. It was forced to anchor offshore upon reaching Hatteras Inlet. A series of raging storms prevented access to Confederate forts. Ships drawing over seven feet, three inches could not pass into the Pamlico Sound. And according to *Harper's Weekly* (February 15, 1862), "No vessel either could pass outside the bar drawing over thirteen feet of water, unless very skillfully piloted." The steamer *City of New York* grounded on the outside of the bar with her foremast and smokestack gone and the ship going to pieces. (Public domain.)

In late August 1899, *Clara E. McGilvery* was sighted about 80 miles southeast of Cape Henry. The *Scranton Tribune*, on September 6, 1899, reported that the ship was dismasted and abandoned in a gale and "nothing was found worth saving and there was no evidence of what had become of the crew." The crew was rescued from the sinking bark by the British steamship *Massapequa*. (Courtesy of National Park Service, Cape Hatteras.)

On January 22, 1894, barkentine *Clythia* stranded in heavy fog on Pebble Shoals near Wash Woods. The Norwegian vessel was traveling from Genoa, Italy, to Baltimore with a cargo of marble. The Life-Saving report notes heavy surf, "making boat service impossible." A crew of 17 was on board. Using the Lyle gun, lifesavers fired a shot to the ship, which lay about 300 yards from shore. Wash Woods Life-Saving Station brought the crew and their personal effects to safety with the help of False Cape Life-Saving Station. The ship was a total loss. *Clythia* was valued at $45,000. Articles of value were saved and sold at auction with the proceeds going to the ship's captain. Many attempts have been made over the years to salvage the 1,100 tons of marble that sank into the sea, which was valued at $29,000. Pictured here is a masthead light credited by the Graveyard of the Atlantic Museum as *Clythia*'s. (Courtesy of Graveyard of the Atlantic Museum.)

The Corolla wreck, named after where it was discovered, is believed to be the oldest shipwreck found off the North Carolina coast to date. Uncovered by a winter storm in 2010, the wreck, dating mid- to late 1600s, is thought to be a merchant ship. It features large timbers held together by wooden pegs and weighs approximately 12 tons. Artifacts were found in the vicinity of the wreck, including coins thought to be from the reigns of Charles I in England and Louis XIII in France and spoons dating to the mid-1600s. With storms covering and uncovering it and the wreck being affected by wave action, it was decided by various groups to relocate the remains. Measuring 37 feet long and 17 feet wide, the shipwreck was moved to the Currituck Beach Lighthouse and then to the grounds of the Graveyard of the Atlantic Museum. (Courtesy of Nathan Richards.)

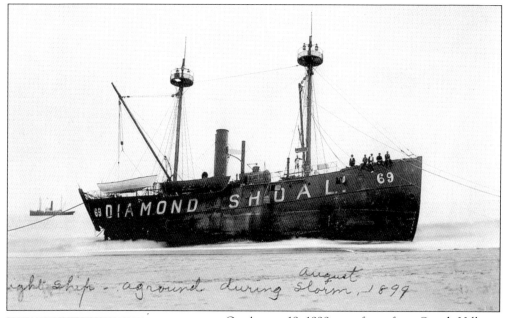

ight Ship - aground during Storm, August 1899

On August 18, 1899, a surfman from Creeds Hill Life-Saving Station noticed a wreck onshore south of the station. The crew loaded up the beach apparatus and within 30 minutes arrived at the scene. They discovered that Diamond Shoals Lightship 69 (LV 69) had "dragged loose from its berth on the outer point of diamond shoals." The ship drifted ashore and stranded—a victim of the San Ciriaco hurricane. (Courtesy of Outer Banks History Center.)

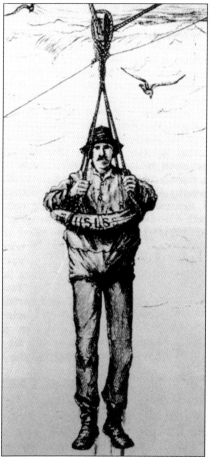

Using the breeches buoy, lifesavers rescued the exhausted nine-member crew of LV-69. Survivors were given dry clothing furnished by the Women's Relief Association. The captain and the Creed's Hill keeper returned to the damaged ship and remained to guard her. Not 27 days later, lifesavers assisted the lightship again, rescuing the crew's belongings after the ship was abandoned due to high seas. Pictured here is an illustration of the breeches buoy by J.H. Merryman. (From *United States Life-Saving Service – 1880* by J.H. Merryman.)

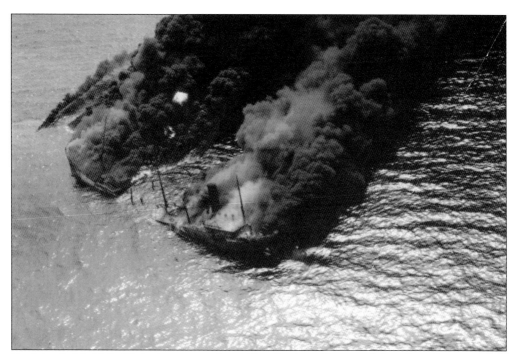

On March 26, 1942, *Dixie Arrow* was about 15 miles from Hatteras Inlet when she was struck by three torpedoes from *U-71*. The tanker, carrying nearly 100,000 barrels of crude oil, buckled amidships, trapping crew and killing deck officers and Capt. Anders Johanson. Able-bodied seaman Oscar Chappell turned the ship into the wind, saving the men trapped by flames on the bow. (Courtesy of Outer Banks History Center.)

The inferno on *Dixie Arrow* blew toward Oscar Chappell, claiming his life. He was posthumously awarded the Merchant Marine Distinguished Service Medal. There were 11 lives lost. The ship was built in 1921 by New York Shipbuilding Corp. in Camden, New Jersey. Owned by the Socony-Vacuum Oil Company, *Dixie Arrow* was propelled by a single-screw reciprocating steam engine. Pictured here is a ship's pump, credited by the Graveyard of the Atlantic Museum as *Dixie Arrow*'s. (Courtesy of Graveyard of the Atlantic Museum.)

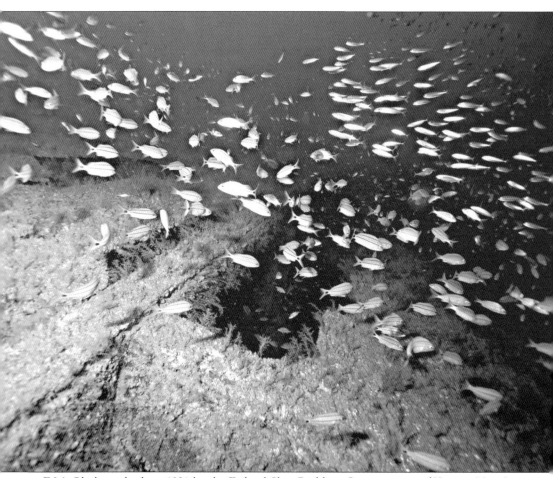

E.M. Clark was built in 1921 by the Federal Ship Building Company out of Kearny, New Jersey. The twin-screw tanker ran shipments of crude oil mostly between the Gulf of Mexico and the Caribbean to ports along the East Coast. It was March 1942 when the seas were frothing from racing U-boat torpedoes; freighters tread carefully through the area dubbed "Torpedo Junction" due to intense enemy activity. *E.M. Clark* had 118,725 barrels of oil aboard and was traveling under stormy skies when the crew experienced a huge explosion. Amid chaos and extreme wreckage, radio operator Earl Schlarb set up an emergency antenna in order to send out an SOS, but the blast of a second torpedo from *U-124* knocked it down. The captain of *E.M. Clark* ordered abandon ship. Pictured here is the starboard side of the ship's stern. (Courtesy of Marc Corbett.)

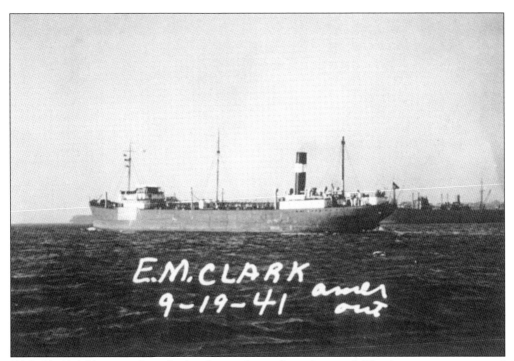

E M. Clark's lifeboat was launched and moved away from the vessel. The departing crew noticed a man still on board the ship. Wearing a life jacket, he jumped into the sea and was pulled into the lifeboat. They plowed through an oil-soaked sea as the ship began to sink. Two ships rescued the men in the lifeboats. USS *Dickerson* picked up 14 men, and the Venezuelan tanker *Catatumbo* picked up 26 men. One crewman was missing. (Courtesy of Gary Gentile.)

On October 1896, the three-masted schooner *E. S. Newman* from Stonington, Connecticut, was on its way from Providence, Rhode Island, to Norfolk, Virginia, when it ran into a storm off Pea Island. On board were two passengers and seven crew members, including Capt. S.A. Gardiner, his wife, and their three-year-old son. Hurricane winds were blowing, and the seas were high. The island was covered with water when the schooner's keel struck bottom. Lifesavers from Pea Island Life-Saving Station came to the rescue. This particular station made history when keeper Richard Etheridge, a black man, was put in charge. The white surfmen refused to work for him, and they quit. Etheridge subsequently hired on an all-black crew, the first in the nation, and served the first black keeper. (Courtesy of Outer Banks History Center.)

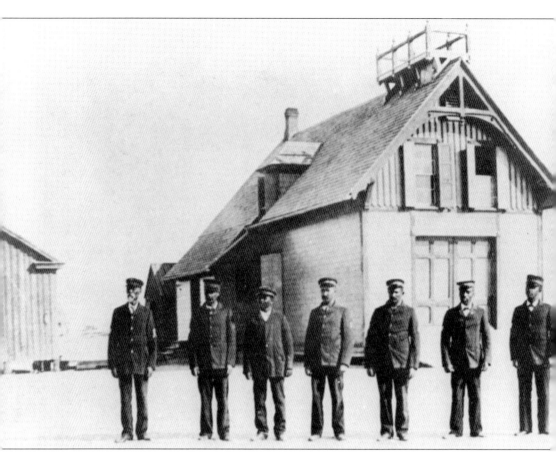

The weather was so fierce on October 11, 1896, beach patrols were stopped. Despite poor visibility, a lookout in the lifesaving tower spotted a red flare from *E.S. Newman*. He responded by lighting a Coston flare and received a signal in return. The odds of rescuing the crew and passengers seemed impossible. With the lifesavers not being able to employ the Lyle gun or the surfboat, a plan was hatched to tie two of the strongest lifesavers together. Carrying a line, they swam through hurricane seas to the ship to begin the rescue. The surfmen took turns, some repeating their effort, and swam back and forth in pairs until all nine were brought to safety. Despite their heroism—and because of their ethnicity—the Pea Island surfmen and keeper did not receive awards for their valor. But in the 1990s, the government was petitioned and posthumously awarded the highest honor, gold lifesaving medals, to the worthy men. Pictured here are Richard Etheridge (left) and the Pea Island lifesavers. (Courtesy of Outer Banks History Center.)

WRECK REPORT.

Cape Lookout Life-Saving Station, ___7th___ District.

Date of Disaster:

___March 15th___, 1902.

1. Name of vessel.	1. Ea,
2. Rig and tonnage.	2. Schooner, Unknown
3. Sailing port and nationality.	3. Unknown, Spanish
4. Age.	4. Unknown.
5. Official number.	5. Unknown.
6. Name of master.	6. V. Garay,
7. Names of owners.	7. Unknown,
8. Where from.	8. Fernandina Fla,
9. Where bound.	9. Hamburg,
10. Number of crew, including captain.	10. Twenty Seven,
11. Number of passengers.	11. None.
12. Nature of cargo.	12. Phosphate and Rosin.
13. Estimated value of vessel.	13. Unknown,
14. Estimated value of cargo.	14. Unknown,
15. Exact spot where wrecked.	15. Outer end of Lookout shoals
16. Direction and distance from station.	16. S+E 1/2 E 11 or 12 miles,
17. Supposed cause of wreck (specifying particularly).	17. Unknown,
18. Nature of disaster, whether stranded, sunk, collided, etc.	18. Stranded
19. Distance of vessel from shore at time of accident.	19. 11, or 12 miles.
20. Time of day or night.	20. Unknown, first saw 3.30 Pm,
21. State of wind and weather.	21. Moderate and Thick.
22. State of tide and sea.	22. Low water and rough
23. Time of discovery of wreck.	23. 3.30 Pm.
24. By whom discovered.	24. Substitute Watter Fulcher
25. Time of arrival of station-crew at wreck.	25. Found no ship first trip
26. Time of return of station-crew from wreck.	26. About 1.35 Am, 16th
27. Were any of the station-crew absent from wreck? If so, who?	27. last trip Kilby Guthrie Whole operation Thomas K Abbon
28. Was life-boat used?*	28. Yes,
29. Number of trips with life-boat.	29. Three of shore. One to wreck
30. Number of persons brought ashore in life-boat.	30. One put on board tug
31. Was surf-boat used?*	31. No.
32. Number of trips with surf-boat.	32.
33. Number of persons brought ashore with surf-boat.	33.
34. Was small boat used?	34.
35. Number of trips with small boat.	35.
36. Number of persons brought ashore with small-boat.	36.

*Specify model or make of boat.

On March 15, 1902, day watch from the Cape Lookout Life-Saving Station sighted the Spanish steamship _Ea_ stranded on the outer shoal. The lifesavers launched a surfboat and headed through the thick mist. According to the wreck report, they searched the area for several hours without discovering a vessel in distress. Come night, they returned to land. Keeper William H. Gaskill telegraphed the revenue cutter _Algonquin_ for help. She arrived early in the morning. Gaskill noted of _Ea_ that "there was no chance to get near enough to her to render assistance she being completely surrounded by a high and dangerous breaker for several hundred yards on every side." Come dawn, the ship was broken in two with both ends submerged. The crew was on top of the bridge. Fortunately, the wind shifted enough for _Ea_ to form a lee. Capt. V. Garry ordered the remaining lifeboat be lowered. Eventually, all 27 men were rescued with help from the lifesavers, a tug, and _Algonquin_. The ship and cargo of phosphate rock and resin were a loss. (Courtesy of Outer Banks History Center.)

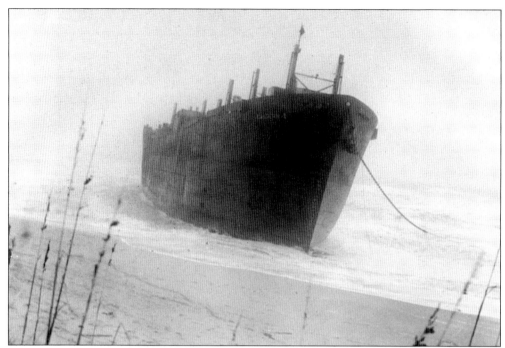

Former Liberty ship *Eastern I*, owned by Mystic Steamship Company of Boston, was built in 1945 as *Streater Seam*. On January 1, 1969, she was being towed by tug *Betty Moran* to Hampton Roads when she went adrift about 60 miles off the Virginia Capes. She grounded in a residential section of Southern Shores. *Betty Moran* and tug *Cherokee* awaited calm seas to salvage the wreck. (Courtesy of Outer Banks History Center.)

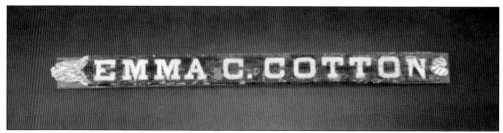

On December 27, 1895, with surf rough and tide rising, three-masted schooner *Emma C. Cotton* stranded north of Pea Island Life-Saving Station. Station crew was assisted by Oregon Inlet Life-Saving Station. *Emma C. Cotton*'s captain requested to wait until daybreak to be rescued. Pea Island keeper Richard Etheridge sent for the surfboat. The following morning, seven crew members were rescued. Shown here is the ship's nameboard. (Courtesy of Graveyard of the Atlantic Museum.)

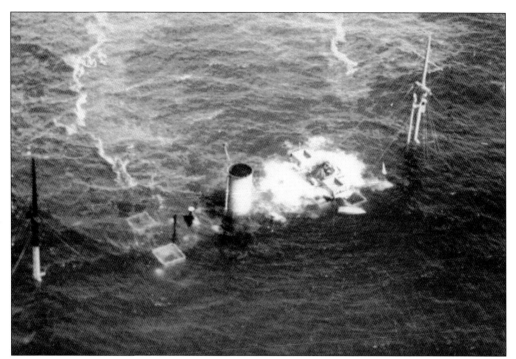

On April 14, 1942, *Empire Thrush* traveled along the Outer Banks carrying a mixed cargo that included 745 tons of gunpowder and TNT. The British ship was to join a transatlantic convoy in Nova Scotia. The freighter was armed and had lookouts on duty as she moved through the sea. She was hit off Cape Hatteras with a torpedo from *U-203* and, due to the explosive nature of her cargo, was immediately abandoned by her 55-member crew. About two hours after the torpedo destroyed part of the hull, the ship sank, and not long after, the crew was rescued by the tanker *Evelyn*. (Courtesy of Gary Gentile.)

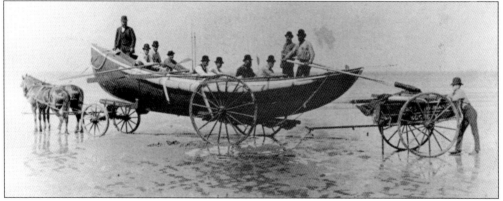

David Stick writes in *Graveyard of the Atlantic* that her decks "were awash" and "only her masts showed above water" when Outer Banks lifesavers stood on shore pondering the rescue of *Ephraim Williams*. It was December 22, 1884, and the seas were "the roughest they had ever seen." No signs of life were visible on the barkentine that lay beyond the farthest breakers. Suddenly, a fluttering flag was seen on the mast. Keeper of the Cape Hatteras Life-Saving Station Benjamin B. Dailey ordered the launching of a lifeboat. With cork belts on, the lifesavers set to sea. The survivors abandoned ship on makeshift rafts. All were rescued. Seven men received gold lifesaving medals of honor. Shown here is a lifeboat like one used in the rescue. (Courtesy of US Coast Guard.)

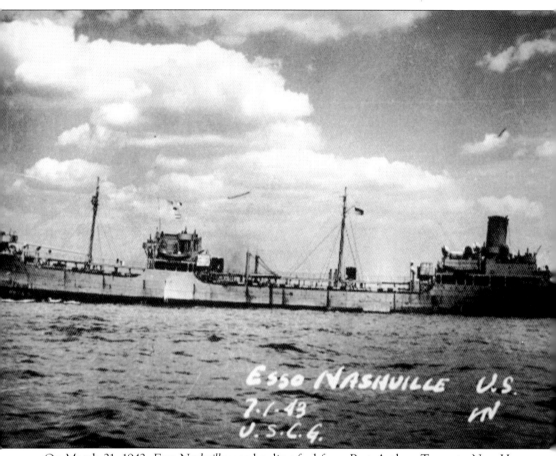

On March 21, 1942, *Esso Nashville* was hauling fuel from Port Arthur, Texas, to New Haven, Connecticut, traveling unescorted and unarmed through known U-boat territory. She was about 16 miles northeast of the Frying Pan Lightship Buoy when she was hit on her starboard side. The torpedo, fired by *U-124*, did not detonate. But she quickly fired again and struck amidships, lifting *Esso Nashville* out of the water. The explosion caused hot oil to rain down on the deck. Officers and crew abandoned ship and were picked up by several vessels. The tanker split in two, and the bow section sank. The remainder of the ship was towed to Morehead City and then to Baltimore, Maryland. (Courtesy of Gary Gentile.)

Two

F.W. Abrams to Northeastern

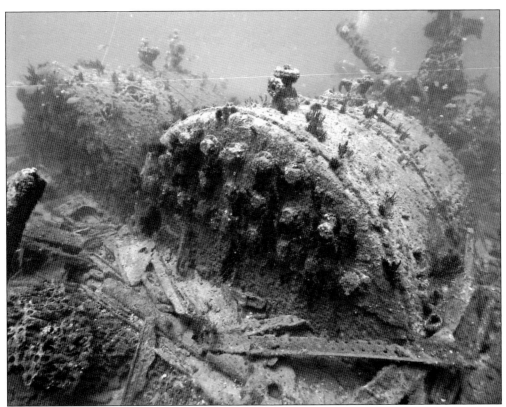

On June 11, 1942, the American tanker *F.W. Abrams* was running with 90,294 barrels of fuel oil. Unarmed, she was escorted by the US Coast Guard, traveling through mine fields placed around Hatteras and Ocracoke Inlets. Moving through rain, *F.W. Abrams*'s crew lost sight of their escort. They spied what they thought was a torpedo wake. An initial blast damaged *F.W. Abrams*, a second explosion hit the vessel, a third explosion skimmed it, and the crew abandoned ship. The ship actually had gone off course and was hit by Allied mines. Shown here are the ship's boilers (front) and steam engine remains (back). (Courtesy of Marc Corbett.)

The Flambeau Wreck is called such because it is visible from time to time on the beach just off Flambeau Street in Hatteras Village. It shows itself in various states depending on how much is uncovered by wind and waves. The remains are believed to be from an early-1900s barge. Visitors to the Graveyard of the Atlantic Museum, which is within walking distance of Flambeau Street, are regularly sent to view the beach wreck because it is often uncovered, is but a stone's throw from the street where parking is available, and provides an up-close view. While her identity is unknown, the beautiful wooden structure has been garnering a lot of attention from beachcombers over the years when weather uncovers her. Volunteers at the museum have been photographing her evolution. (Courtesy of Graveyard of the Atlantic Museum.)

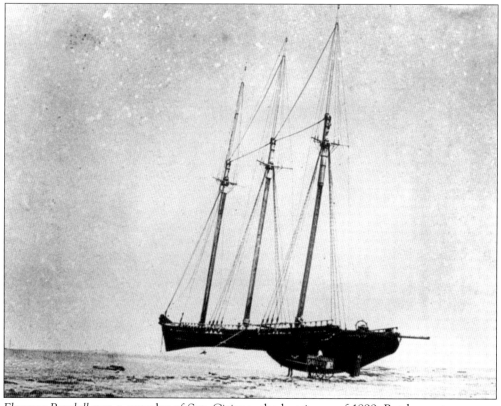

Florence Randall was a casualty of San Ciriaco, the hurricane of 1899. But her outcome was significantly better than that of *Aaron Reppard*. The 741-ton three-masted schooner was traveling with a load of fish scraps from New York to Charleston, South Carolina, when she grounded on August 16 about two miles south of the Big Kinnakeet Life-Saving Station. The lifesavers from the station sent out a shot that reached the ship. Using the breeches buoy, surfmen safely brought to shore all passengers and crew of *Florence Randall*—Capt. C.A. Cavillier, his wife, and eight men. The ship and cargo of fish scraps were a total loss. The estimated value of the wreck was $15,000 with the cargo valued at $4,000. A total of 17 ships were lost in the hurricane; six disappeared without a trace. (Courtesy of National Park Service, Cape Hatteras.)

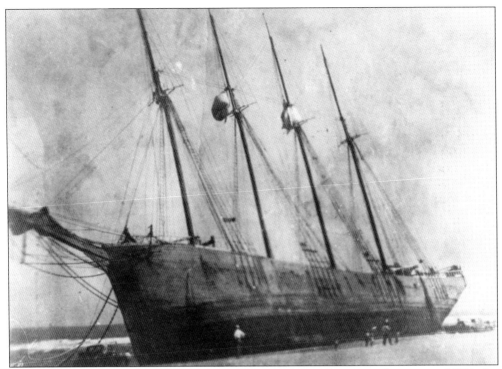

The four-masted schooner G.A. *Kohler* was grounded during the August hurricane of 1933. On August 23, she was seen stranded a mile south of the Gull Shoal Life-Saving Station, enduring the worst of the storm. Gull Shoal and Chicamacomico Life-Saving Stations were both nearby. According to historian David Stick, despite seeing distress signals, the lifesavers had to wait until a "break in the storm" the next day to "put a line aboard" the vessel. (Courtesy of National Park Service, Cape Hatteras.)

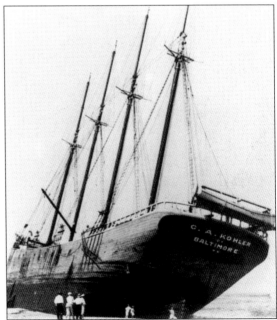

Lifesavers rescued the eight men and one woman on board G.A. *Kohler*. The schooner sat proudly on the beach beyond the tides for 10 years before she was burned to salvage her scrap iron for war. Remains of G.A. *Kohler*, one of the last of the large sailing vessels, are occasionally uncovered onshore and photographed by area lens-folk. Her oak timbers continue to present a glorious site. (Courtesy of National Park Service, Cape Hatteras.)

GEO. M. ADAMS

The schooner *George M. Adams* stranded off Nags Head on May 1, 1897. It was 4:00 a.m. when the patrolman on duty from the Nags Head Life-Saving Station discovered the wreck and "discharged his night signal." The Nags Head keeper called for assistance from the Bodie Island Life-Saving Station. An hour and 45 minutes later, help arrived at the scene, and a shot was launched. Using the breeches buoy, they brought the master to shore. He did not want the remainder of the crew to abandon the ship at this time, but while discussing the matter, the vessel moved close to the beach, "broadside on," and the crew of eight sailors launched a yawl and "making fast to the whip line of the buoy" were hauled ashore. The 641-ton ship, from Bath, Maine, valued at $12,000, was sold at public auction. This is the ship's nameboard. Quoted material is from the *Annual Report of the Operations of the United States Life-Saving Service for the Fiscal Year Ending June 30, 1897*; an excerpt of the report is available at northcarolinashipwrecks.blogspot.com. (Courtesy of Graveyard of the Atlantic Museum.)

WRECK REPORT.

Cape Hatteras *Life-Saving Station, District No.* 6

Date of Disaster:

May 22nd, 1896.

		
1.	Name of vessel.	Glanayron
2.	Rig and tonnage.	schooner 1631
3.	Hailing port and nationality.	Aberystwyth British
4.	Age.	1 year
5.	Official number.	96607
6.	Name of master.	Evan Lloyd
7.	Names of owners.	John Mathias & Co
8.	Where from.	Fernandina
9.	Where bound.	Rotterdam via new bottom
10.	Number of crew, including captain.	23 twenty three
11.	Number of passengers.	none
12.	Nature of cargo.	phosphate
13.	Estimated value of vessel.	$10025
14.	Estimated value of cargo.	$2000
15.	Exact spot where wrecked.	S.W. Point outer Diamond Shoals
16.	Direction and distance from station.	S.S.E 11 miles
17.	Supposed cause of wreck (specifying particularly).	Hazy light showed bad
18.	Nature of disaster, whether stranded, sunk, collision, &c.	stranded
19.	Distance of vessel from shore at time of accident.	11 miles
20.	Time of day or night.	7-45 Pm
21.	State of wind and weather.	Strong SW Hazy
22.	State of tide and sea.	low water sea strong
23.	Time of discovery of wreck.	849 Pm
24.	By whom discovered.	E.J Midgett surfman no 7
25.	Time of arrival of station-crew at wreck.	about 7 am on the 23rd
26.	Time of return of station-crew from wreck.	about 11-45 am
27.	Were any of the station-crew absent? If so, who?	none absent
28.	Was life-boat used?	no
29.	Number of trips with life-boat.	
30.	Number of persons brought ashore in life-boat.	
31.	Was surf-boat used? Monomoy	Monomoy used
32.	Number of trips with surf-boat. Monomoy	one
33.	Number of persons brought ashore with surf-boat.	23 Monomoy
34.	Was life-raft used?	no
35.	Number of trips with life-raft.	
36.	Number of persons brought ashore with life-raft.	

According to the official wreck report on May 22, 1896, *Glanayron*, from Aberystwyth, Wales, ran aground on Outer Diamond Shoals off Cape Hatteras. The captain blamed the light on the cape for his mishap, which he said "seemed to show indistinctly." The keeper from the Cape Hatteras Life-Saving Station saw the distress rocket in the night sky and answered with a Coston flare. Three Life-Saving stations—Cape Hatteras, Little Kinnakeet and Creeds Hill—decided to wait until daylight to launch lifeboats due to the lack of visibility and heavy breakers. At daybreak, the surfmen, battling strong seas, set out to rescue the 23-member crew, taking about seven hours to move back and forth from the ship. The freighter had been carrying 1,631 tons of phosphate valued at $36,000 on its way to Rotterdam from Fernandina, Florida. The vessel, valued at $130,000, was a total loss. (Courtesy of Outer Banks History Center.)

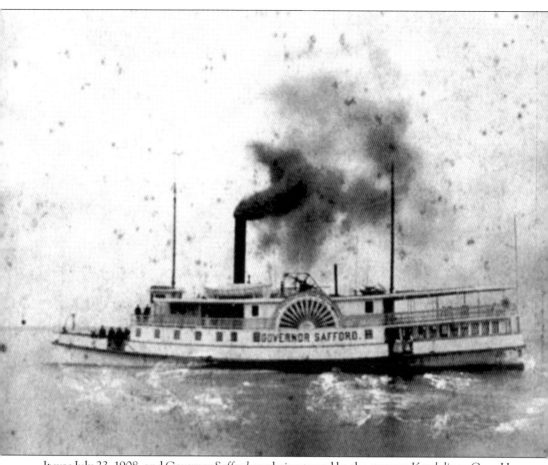

It was July 23, 1908, and *Governor Safford* was being towed by the steamer *Katahdin* to Cape Henry when she met with trouble. Built in 1884 in Camden, New Jersey, and owned by the Atlantic Coast Lumber Company Corporation, the 307-ton, wooden-hulled, side-wheel steamer was being run by Capt. Dick Turpin. They started out in calm seas, but the weather turned rough, and the ship's starboard guards started to give way. Debris clogged the pumps in the bilge. As the weather worsened, the towline parted. Machinery continued to break down. They slowly steered for Beaufort Inlet. Attempts to tow the ship failed. The crew abandoned ship and rowed to *Katahdin*. *Governor Safford* sank off Bogue Inlet on July 24 in about seven fathoms of water and has never been found. (Courtesy of State Archives of Florida, Florida Memory.)

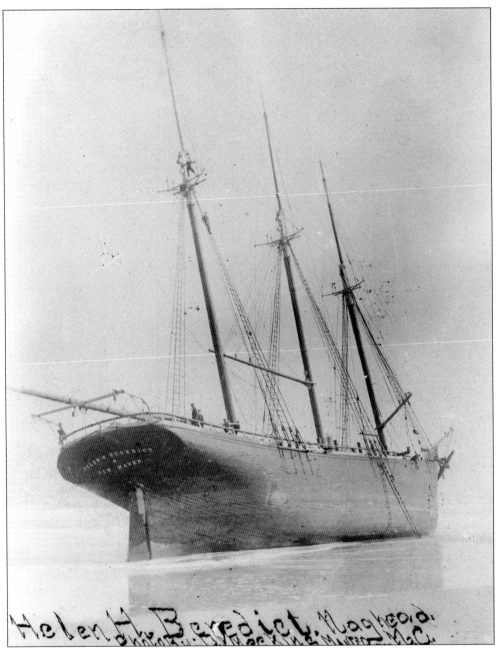

On February 6, 1914, the three-masted schooner *Helen H. Benedict*, of New Haven, Connecticut, was traveling to Fernandina, Florida, when she went ashore during a winter gale at Nags Head. The wreck report from District 7 states she was a 33-year-old vessel captained by W.W. Torrey and carrying seven crewmen, which differs from a *New York Times* report stating there were nine men on board. The crew from the Nags Head Life-Saving Station rescued those on board via the breeches buoy and provided shelter and food for them. No one was reported lost. The station provided the crew a total of 177 meals before they departed. The cook and four seamen were sheltered there for five days while the captain and mate departed after 17 days. (Courtesy of Outer Banks History Center.)

The steamer *Hesperides* was a 2,404-ton freighter employed to carry cargo and passengers from Argentina to Europe. On October 4, 1897, she left Santiago de Cuba for Baltimore, Maryland, carrying 1,394 tons of iron ore. The weather was calm, but a thick fog set in. Unbeknownst to the crew, a strong current set the ship west of her course. *Hesperides* crossed the edge of the Gulf Stream and was not, as thought, more than 200 miles from Cape Hatteras. As a result, the ship's master, Capt. Owen Williams, set a course that had the vessel passing at least 20 miles to the east of Diamond Shoals. Believing themselves to be on course, they did not take soundings to determine the depth of water. The steamer ran aground on the shoals with six feet of water accumulating in the engine room. The 24-member crew was rescued by lifeboat. *Hesperides* was declared a total loss. The mishap was investigated, and the captain and first mate were found innocent of any wrongdoing. (Courtesy of Uhle Collection, Steamship Historical Society Archives.)

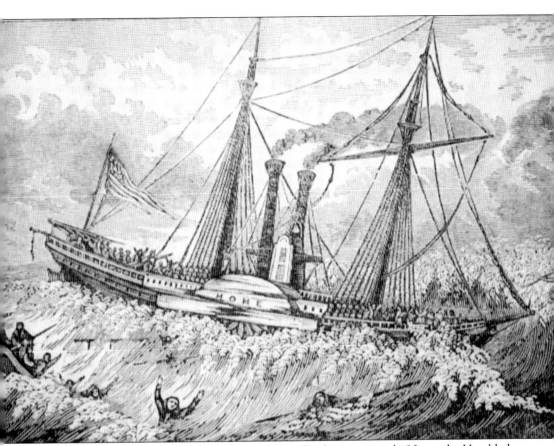

The wreck of *Home* on October 9, 1837, led to the death of approximately 90 people. Heralded for her beauty and speed, the sleek steamboat was carrying about 130 passengers when she left New York. Designed for river trade, the 550-ton side-wheel steamer ran into a hurricane, known as "Racer's Storm," and began taking on water. The pumps could not keep the water at bay, and passengers helped bail. *Home* was jerking wildly in the waves with her paddle wheels in the air and bow lifting and crashing down onto the sea. The water eventually put out the ship's fire. *Home* struck shore about six miles northeast of Ocracoke Village. There were only two life preservers on board, lifeboats were smashed or overturned, and people were tossed from the forecastle into the sea. Some managed to swim or float to shore, including one woman tied to a settee who was assisted by islanders on the beach. Forty people survived. The wreck led Congress to pass a law requiring ships to carry one life preserver per person. (Courtesy of Gary Gentile.)

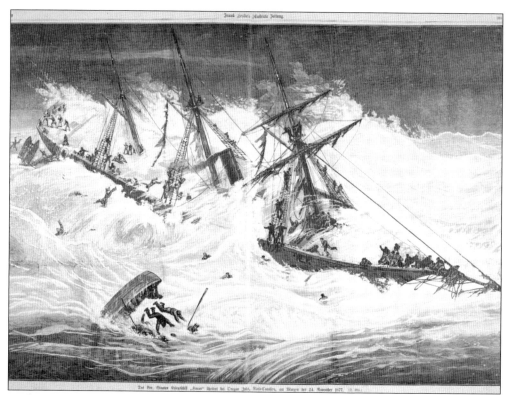

With over 2,000 shipwrecks in the Graveyard of the Atlantic, the story of USS *Huron* alone could fill chapters. Despite storm warnings, the naval ship, referred to as "the strongest hull in the Atlantic waters," set sail from Norfolk, Virginia, on November 23, 1877. (Courtesy of the State Archives of North Carolina.)

Reports of the number of crew on board *Huron* varies between 132 and 138. Comdr. George P. Ryan took the two-year-old ship out the mouth of the Chesapeake Bay into gale-force winds and powerful seas. Built of five-eighths-inch iron and weighing 541 tons, the barkentine-rigged screw steamer set course, moving between the Gulf Stream and the infamous Outer Banks coastline. Pictured here is a shoe from *Huron*. (Courtesy of Graveyard of the Atlantic Museum.)

Despite the watch changing hands like clockwork, a fatal error occurred when a bend in the coastline was not taken into account. Undercover of fog with ferocious seas breaking over the vessel, she hit hard aground and listed to her port side. The wreck of USS *Huron* saw a catastrophic loss of life. The numbers differ depending on the source, but it is believed that anywhere between 103 and 110 people lost their lives. Pictured here is US Navy silverware from *Huron*. (Courtesy of Graveyard of the Atlantic Museum.)

U.S. Navy silverware

Fierce winter seas prevented *Huron*'s crew from swimming the 200 yards to shore. Due to seasonal closures of Life-Saving stations, nature washed away hope and life. Coupled with the loss of 85 lives on *Metropolis* two months later, the tragedies brought harsh criticism upon the federal government, illustrating the need for additional months of lifesaving operations. Shown here is a Remington pistol from *Huron*. (Courtesy of Graveyard of the Atlantic Museum.)

On December 13, 1914, SS *Isle of Iona*, a British transport steamship, ran aground on her way from Daiquirí, Cuba, to Baltimore, Maryland. In thick fog, the 3,789-ton cargo ship wrecked near Hatteras Inlet while carrying a load of iron ore. Surfmen from Durants and Hatteras Inlet Life-Saving Stations came to the rescue. All 27 men survived. Pictured here is a thimble from the ship. (Courtesy of Graveyard of the Atlantic Museum.)

In mid-September 1944, *Jackson*, a US Coast Guard cutter, was traveling with her sister ship *Bedloe* in a convoy to help aid a torpedoed Liberty ship. They got caught in a hurricane. Winds were blowing over 100 miles per hour and visibility was poor when *Jackson*, running about 12 miles off Bodie Island, capsized and turned on her port side. Her crew clung to life rafts drifting in a stormy sea. *Bedloe* also capsized in the storm. As the Coast Guard was busy with land-based rescues due to the storm wreaking havoc on the island, it took two days for a number of seaplanes and a rescue boat to pick up survivors from both vessels. (Courtesy of Gary Gentile.)

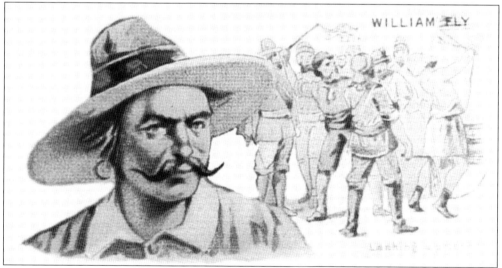

In 1726, William Fly, a boatswain aboard the snow *Elizabeth*, rallied the crew and committed mutiny during a voyage. They murdered the captain and mate before sailing on to North Carolina. Fly spied the sloop *John and Hannah* off Hatteras. Her captain offered his services as a pilot to help them navigate the coastal waters before discovering that Fly and crew were "gentlemen of fortune." The pirates attempted to sail the sloop out to sea but struck a shoal and took on water. They scuttled her and set part of the hull on fire. (Public domain.)

Sources differ as to the date of the sinking of the bark *Josie Troop*. Some date it February 22, 1889, and others have it at February 23 of the same year. The ship was traveling from London to Philadelphia carrying two million pounds of chalk. The 1,099-ton vessel, under the command of W.G. Cook, was said to have been caught in a gale and wrecked at Chicamacomico. The *St. Paul Daily Globe* in St. Paul, Minnesota, ran a peculiar headline on February 24, 1889: "The Bark Josie Troop Wrecked on the Rocky North Carolina Coast." What is odd is that anyone who knows the Outer Banks area, knows it does not have a rocky coast, unless one is referring to a stormy ocean offering a rocky ride. The crew from Life-Saving Station No. 19 was only able to save six crew members. Eleven men died. The vessel and cargo were a total loss. Chalk washed up on the beach at the time of the wreck, and even today, occasionally does from time to time. (Courtesy of Graveyard of the Atlantic Museum.)

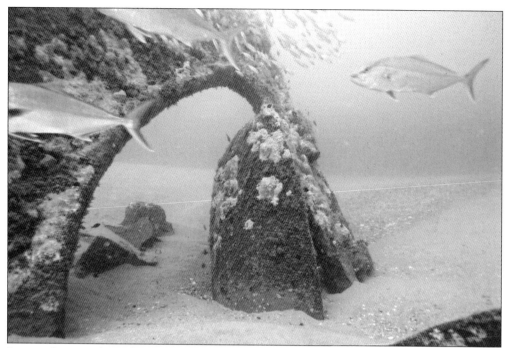

Imagine being in dense fog in a territory where U-boats were picking off ships like a sharpshooter in a country fair shooting gallery. On March 17, 1942, *Kassandra Louloudis* found herself in such a position. The Greek freighter was carrying an assortment of cargo and making her way through fog on her way to Cristobal, Panama. Shown here is her stern, king post, and prop, which is partly buried in the sand. (Courtesy of Marc Corbett.)

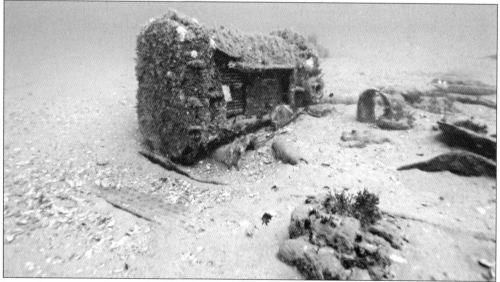

It was dinnertime when crew of *Kassandra Louloudis* heard an SOS come across the radio from the tanker *Acme*. The cause was a torpedo hit that took out a third of *Acme*'s crew. The Navy responded quickly by dropping depth charges. The Coast Guard also advanced to the scene. Pictured here is *Kassandra Louloudis*'s donkey boiler, which fell from the wreck. (Courtesy of Marc Corbett.)

The captain of *Kassandra Louloudis*, Themis Millas, changed his course and was able to see a rescue in action. With the *Acme* situation appearing under control, Millas moved west, hugging the coast, when suddenly a torpedo from *U-124* whizzed through the water toward the freighter. Pictured here are ampules of lidocaine thought to be from *Kassandra Louloudis*. (Courtesy of Graveyard of the Atlantic Museum.)

The torpedo missed by 20 feet, but a second torpedo was launched and struck *Kassandra Louloudis* on the port side. An SOS was sent out. The lifeboats were launched. There were no fatalities, and the 35-member crew was picked up by the Coast Guard cutter *Dione*. *Kassandra Louloudis* sank, but *Acme* was towed to safety. Pictured are double truck tires and an axle shaft off the ship. (Courtesy of Marc Corbett.)

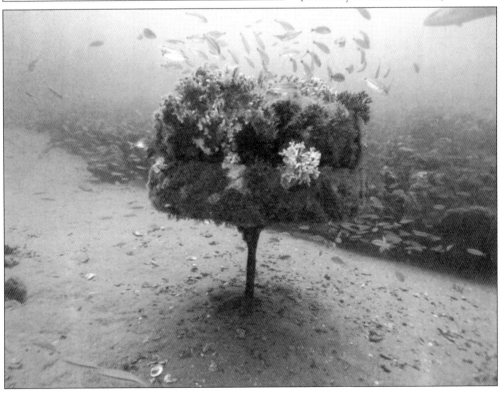

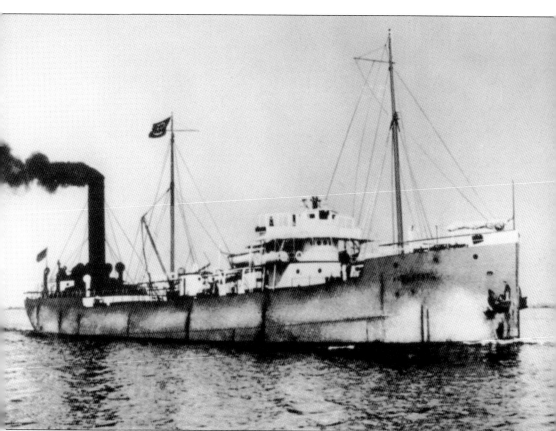

It was December 3, 1927, and a winter storm with gale-force winds wreaked havoc on the tanker *Kyzickes*. Hailing from Greece and headed from Baltimore to Seville, Spain, the ship's crew transmitted the condition as so serious, and if not quickly heeded, the consequences would prove deadly. Powerful seas caused the leaking ship to drift against her will. Her pumps could not keep the ocean at bay. A ship reached the area where *Kyzickes* was supposed to be, but the tanker could not be located. Night came, and the sea swept away four of her crew. Come dawn, *Kyzickes* was caught in a pounding surf, having grounded on a shoal off Kill Devil Hills. Her predicament: the 2,627-ton vessel was beginning to break apart. Crew members were clinging to the masts. Help came from the Kill Devil Hills and Kitty Hawk Life-Saving Stations. Lifeboats were useless in the raging sea. They turned to the Lyle gun and breeches buoy. The 24 survivors were brought to safety. Pictured here is future *Kyzikes* as *Paraguay*. (Courtesy of Historical Collections of the Great Lakes.)

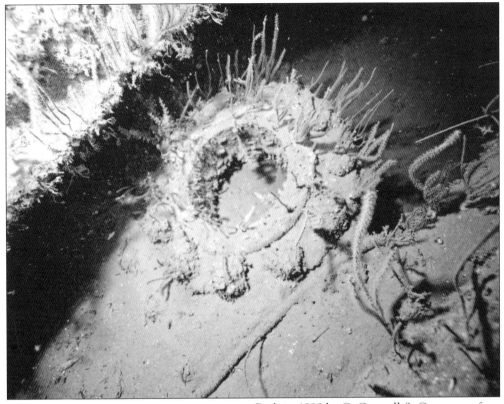

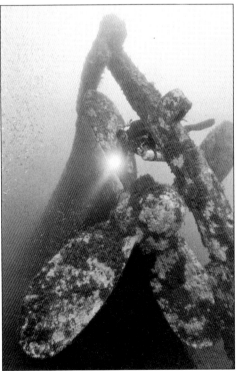

Built in 1898 by C. Connell & Company of Glasgow, Scotland, *Lancing* was converted from a coal-burning whaling factory to an oil-fired steamer used to transport fuel oil for the British Isles. On her final war-effort cruise, the 7,866-ton vessel was carrying 8,802 tons of marine fuel oil from Curaçao to England. She was armed and had lookouts in place. Shown here is a brass pipe fitting on *Lancing*'s port side. (Courtesy of Marc Corbett.)

On April 7, 1942, *U-552* torpedoed *Lancing*, putting a hole in her starboard side. Due to fast flooding in the engine room, crewman Emil Hansen drowned. Capt. Johan Bjerkholt ordered the ship abandoned. Not being able to radio for help, 49 survivors waited approximately five hours before two ships, *Pan Rhode Island* and HMS *Hertfordshire*, came to the rescue. Shown here is *Lancing*'s prop. (Courtesy of Mike Boring.)

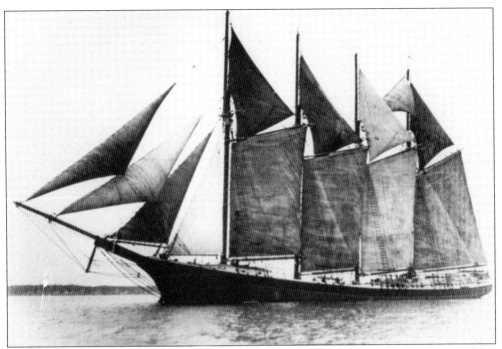

The schooner *Laura A. Barnes* was shipwrecked on June 1, 1921, off Bodie Island. Hailing from Marble Head, Massachusetts, she was traveling in ballast under the command of Capt. C.H. Barnes. The wreck was discovered shortly after midnight by surfman H.N. Etheridge. (Courtesy of National Park Service, Cape Hatteras.)

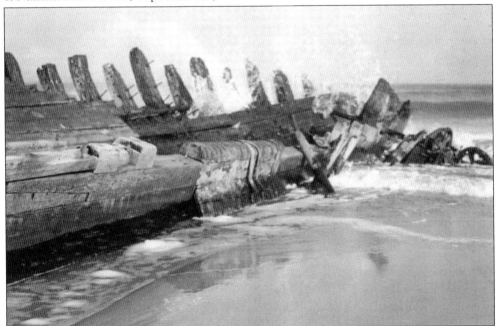

Laura A. Barnes had been traveling under fog through high seas, wind, and strong tide when she grounded about one mile north of Bodie Island. All eight crew members were rescued. The ship, valued at $80,000, was a total loss. (Courtesy of National Park Service, Cape Hatteras.)

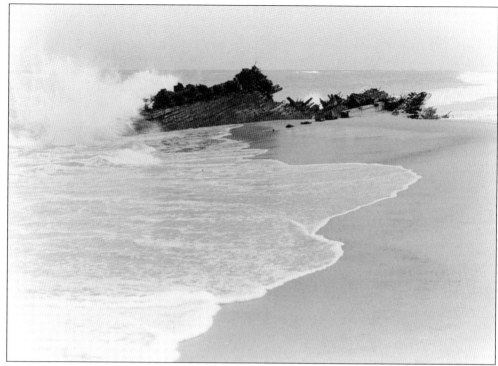

Laura A. Barnes helped the R.L. Bean Shipyard set a record for the most four-masted schooners built during a 20-month period along the coast and also "at any shipbuilding plant in Maine in any previous 20 months," according to the *Camden (Maine) Herald*. (Courtesy of National Park Service, Cape Hatteras.)

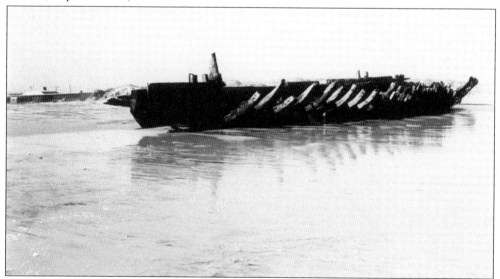

Having been christened by the captain's wife, for whom the ship was named, *Laura A. Barnes* went from a vessel outfitted with all the modern conveniences to a pile of metal, hardwood, spruce, and pine decaying on a barrier island beach. Part of her remains are visible on the grounds of the Graveyard of the Atlantic Museum in Hatteras Village. (Courtesy of National Park Service, Cape Hatteras.)

On March 18, 1942, crew from the freighter *Liberator* spotted a vessel resembling a U-boat. Armed and ready for action, *Liberator* struck the ship with two shots. The victim turned out to be an ally, USS *Dickerson*, a destroyer patrolling the area in a blacked-out state. Four men, including the *Dickerson*'s captain, died as a result of the action. Seven were injured. USS *Dickerson* did not sink. Come dawn, *Liberator* was in the vicinity of Diamond Shoals. (Courtesy of Hal Good.)

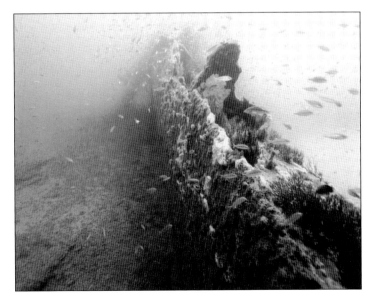

U-332 maneuvered itself into position close to the shoals and fired toward the sea in broad daylight. Her torpedo tore into *Liberator*, taking out the engine room and deck above it. An SOS was transmitted before the ship was abandoned. Less than a half hour later, *Liberator* sank. The 35 survivors, in lifeboats, were picked up by the Navy tug *Umpqua*. Pictured is the ship's disarticulated hull. (Courtesy of Marc Corbett.)

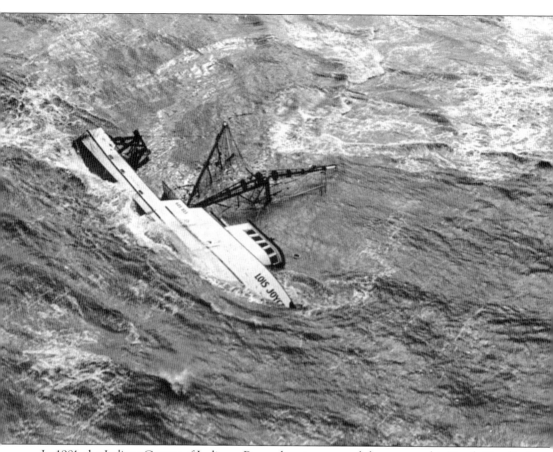

In 1981, the *Indiana Gazette* of Indiana, Pennsylvania, reported that a storm hit North Carolina's Outer Banks hard. On November 12, winds were said to be blowing up to 60 miles per hour with offshore waves measuring 15 feet. Due to the nor'easter, the trawler *Lois Joyce* ran aground in Oregon Inlet. The newspaper account says she was refloated with the help of a tugboat the following day. The grounding was the precursor of a more serious occurrence for possibly the same commercial vessel. The National Park Service reports a trawler called *Lois Joyce* sank in Oregon Inlet in December 1981. Yet other sources have her sinking the following year in December. No matter the year, the National Park Service reports the crew was rescued by a Coast Guard helicopter, and the $1 million trawler was a total loss. *Lois Joyce* is a dive spot located on the northern ocean-side hook at the mouth of Oregon Inlet. It can be seen at low tide. (Courtesy of Eve Turek.)

LST-471 was built in 1942 for the US Navy by the Kaiser Shipbuilding Company. During the war, she was assigned to the Asiatic-Pacific theater. The landing ship tanker participated in operations from September 1943 until July 1945 at Leyte, Lingayen, Mindanao, and Balikpapan. She did a spell in dry dock for repairs following an aerial attack off New Guinea. Shown here is a brass pipe flange and the side of a local LST wreck, believed to be LST-471 by diver Marc Corbett. (Courtesy of Marc Corbett.)

The 328-foot LST-471 earned multiple battle stars for her duty during the war. Following World War II, she was purchased for scrap metal. The craft was on her way to the scrapyard when a storm hit, causing her to run aground off Rodanthe. The ship was a total loss. Shown here is a brass hinge from a local LST, believed to be LST-471 by diver Marc Corbett. (Courtesy of Marc Corbett.)

U-boat activity was intense off the Outer Banks during 1942, and the siting of an 11-ship convoy made for a perfect target in late June. Kapitänleutnant Von Bulow of *U-404* was ready and fired into the vessels. *Manuela*, captained by Conrad Nilsen, was hit. The 4,772-ton freighter's bulkhead, between the boiler room and engine room, was destroyed. Three crewmen were killed. Pictured here is the ship's engine room. (Courtesy of Marc Corbett.)

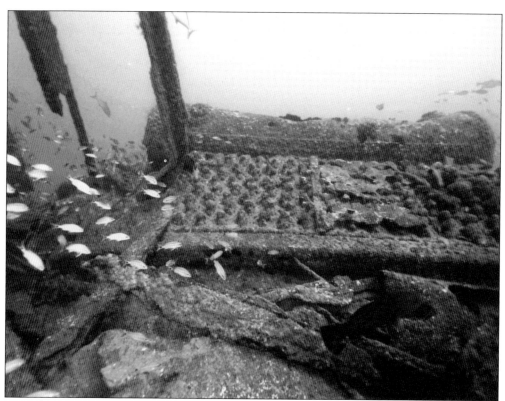

Manuela crew abandoned ship in a lifeboat and several rafts. Thankfully, the ship did not sink for a crew member was found on board the next day. A salvage tug attempted to tow *Manuela* but lost the battle, with her eventually sinking. She was valued at $1.5 million, and her general cargo was valued at $704,000. Surviving crewmen were picked up by *Norwich City* and CGC 483. Four crew were missing. Pictured here is the ship's steam boiler. (Courtesy of Marc Corbett.)

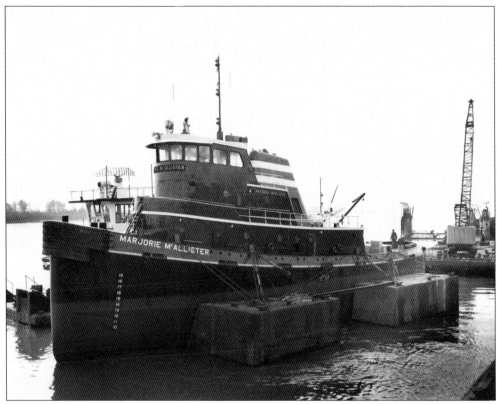

On November 2, 1969, motor-towing vessel *Marjorie McAllister* disappeared 17 miles south of Cape Lookout. She was traveling alone in stormy seas from New York to Jacksonville, Florida. Her demise was attributed, in part, to foundering due to weather, engine room flooding, and the vessel suddenly capsizing. Also cited were ship design flaws. (Courtesy of Craig Rising, McAllister Towing.)

Marjorie McAllister's captain was faulted for proceeding into the storm instead of seeking refuge in the Chesapeake Bay area. Multiple search and rescue attempts were made. Searchers found debris and equipment from the vessel; however, the six crew members were considered dead. *Marjorie McAllister* was located in 1972 and salvaged. She was sold and renamed twice before being purchased in 1999 by McAllister Towing and Transportation of New York and renamed *Mary L. McAllister*. (Courtesy of Wayne Strickland, Scuba South.)

On August 6, 1918, the freighter *Merak* was spotted by *U-140*, which surfaced near Diamond Shoals Lightship 71 (LV-71) and began firing on the steamer. *Merak* zigzagged full speed ahead before grounding on the edge of Diamond Shoals. After coming under fire again, *Merak*'s 43 men abandoned ship. *U-140* then placed a bomb on board *Merak* and sank her. The submarine turned toward the lightship. Shown here is the stern believed to be *Merak*'s. (Courtesy of Marc Corbett.)

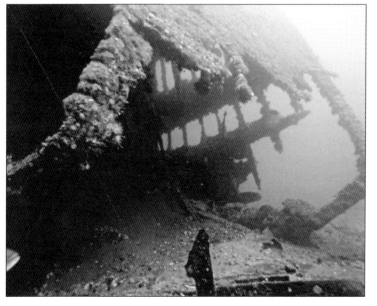

U-140 fired on the lightship. A yawl was lowered into the water, and the crew of 12 shoved off from the chained and anchored vessel. It took seven hours for them to reach the shore. Meanwhile, one of *Merak*'s boats made it to shore, and the other was picked up by the steamship *Adonis*. Pictured is the upside-down bow of a ship believed to be *Merak*. (Courtesy of Marc Corbett.)

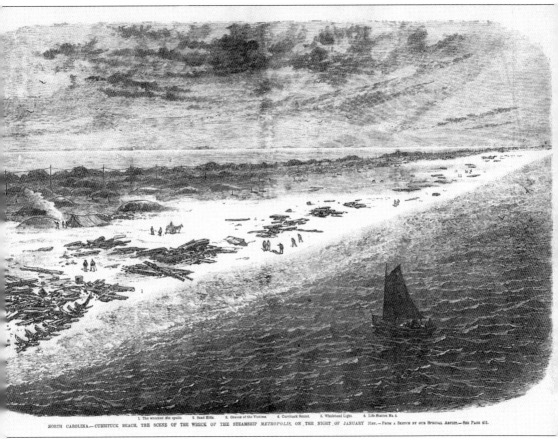

On January 29, 1878, there were 258 people on board the bark-rigged screw steamer *Metropolis* when she left Philadelphia for her journey to Brazil. Carrying 215 to 220 laborers hired to help build a 180-mile railroad, *Metropolis* was also transporting 1,000 tons of cargo, including iron rails. On January 30, the seas turned rough. According to historian David Stick, the steamer was "laboring heavily," and it was challenging to keep the engines running. A leak was discovered near the rudder post, and water rose waist-deep in the hold. The crew lightened their load by throwing about 50 tons of coal overboard to help the circulating pumps catch up with the water pouring in. One account states that the iron rails shifted, and open seams in the hull widened. The pumps broke down. A massive wave washed over the ship, stealing the steam whistle, smokestack, engine room ventilators, seven lifeboats, after-mainsail, starboard saloon, and much of the gangway. An assistant steward was crushed by a toppled galley stove. *Metropolis* was disabled with her engines drowned out. (Courtesy of North Carolina Collection.)

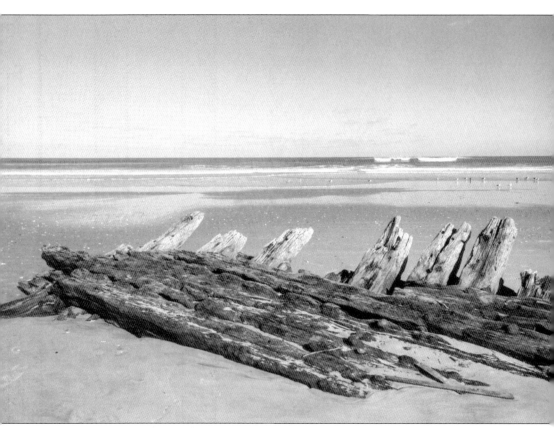

Metropolis was steered toward the shore. It came to rest on an inner bar about 100 yards from the beach. Three men swam through massive breakers to shore, and six made it there in a lifeboat. Life-Saving Station No. 4 went to the scene dragging heavy apparatus through sea-soaked sand. Their second shot landed on the ship but got hung up and broke. They ran out of powder and had to get more. A man put a rope in his mouth and swam to shore, but the rope on the ship's end ran out. The mainmast fell. The rest of the cabin washed overboard, taking more lives. One person rode a door to shore. Many swimmers were killed by debris or from being carried out to sea and dying from exhaustion. The lifesavers, already fatigued from previous work, dragged people from the surf. They took harsh criticism for their lack of preparation. All told, 85 people died. This northern beach wreckage is attributed by some as belonging to *Metropolis*. (Courtesy of Eve Turek.)

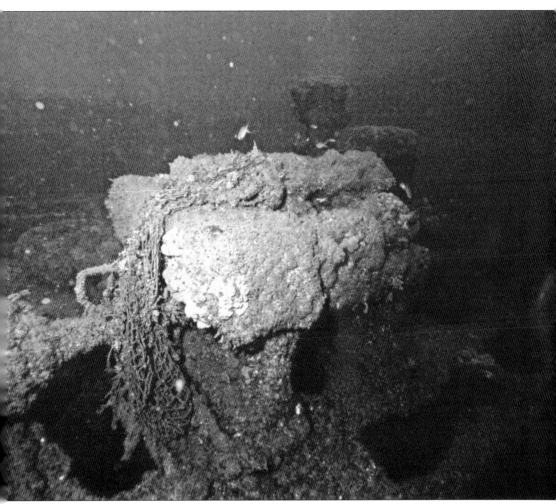

On September 15, 1903, a gale was blowing, and Captain Sorenson, on the steamer *Vidar*, heard several cries from his cabin. He went to the bridge to investigate and spotted something in the water "like a small log, about a half a mile off. . . . With the aid of my glass I found it to be a small hatch, with a man in oilskins stretched full length on it." Sorenson steered *Vidar* toward him and rescued the man, who was completely incapable of speech. Seeing no more wreckage, the captain started on his way. After traveling a mile, he spotted five men clinging to wreckage. They too were rescued. "One was nearly crazy," reported the captain. "My men had to hold him in the life boat for he was determined to jump into the sea." The men were from the steamer *Mexicano*. Shown here is deck machinery from *Mexicano*. (Courtesy of Marc Corbett.)

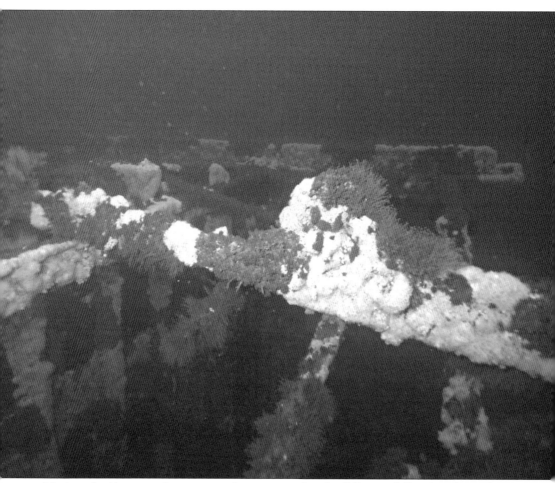

Mexicano had been caught in a severe hurricane and sank off Currituck Beach Light. "A heavy sea swept the steamer from stem to stern, carrying away lifeboats and ventilators, flooding the engine rooms and putting out the fires," said survivor August Osterlind, a native of Finland. Caught "in the trough of the sea," the ship tossed for about an hour before sinking stern first into the water. Several crew members refused to leave the ship. Pistol shots were heard with speculation being that some of the officers preferred dying that way to drowning. Crew drifted on wreckage for hours before one man gave up and went down. There were 23 men on board the ship. Six were saved by *Vidar*. It is thought that an additional steamer might have rescued other crew. Pictured here is the top of the ship's hull. (Courtesy of Marc Corbett.)

Modern Greece was an English-built steamer of about 1,000 tons that was doing an early-morning run in the Cape Fear area in an attempt to outrun Federal blockaders. On June 27, 1862, she was chased ashore by a Union ship, with all crew escaping. Seen here, a recovered cannon is carried by a bulldozer. (Courtesy of Outer Banks History Center.)

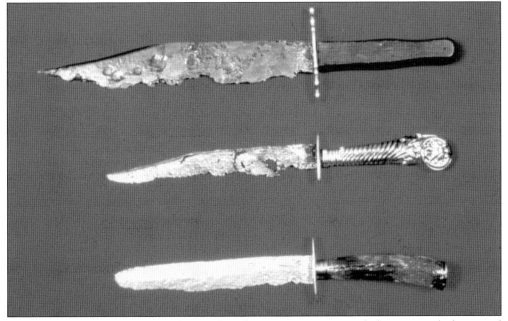

Troops from Fort Fisher removed part of *Modern Greece*'s cargo, including guns, clothing, and liquor. The coastal waters from Topsail Island to Shallotte are filled with many a steamer that attempted to outrun multiple lines of blockaders by sailing close to shore under cover of darkness. Shown here are artifacts from the ship. (Courtesy of Outer Banks History Center.)

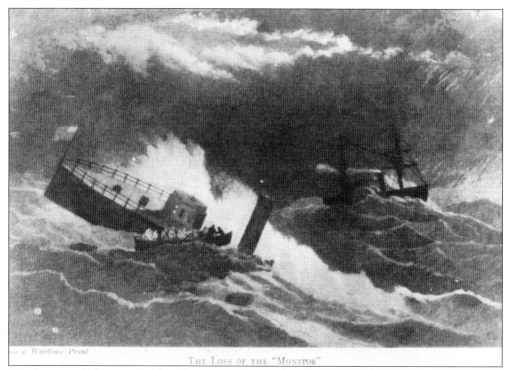

The first ironclad put out by the Union army during the Civil War was *Monitor*, complete with a revolving turret. The ship engaged in a famous battle in Virginia with *Merrimack* (CSS *Virginia*). The 172-foot-long vessel was built low so that her turret and pilothouse were just visible above the water. This design gained her the nickname "cheesebox on a raft." (Courtesy of US Naval Historical Center.)

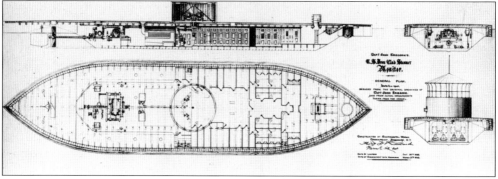

In late December 1862, *Monitor* was on her way from Virginia to South Carolina with 65 men on board. She was accompanied by the side-wheeled steamer *Rhode Island* when they ran into foul weather. *Rhode Island* took *Monitor* in tow as they moved toward Cape Hatteras. (Courtesy of US Naval Historical Center.)

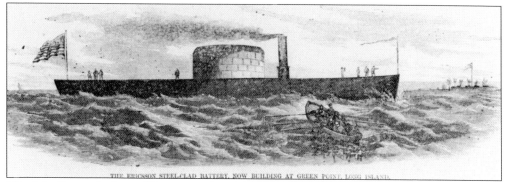

THE ERICSSON STEEL-CLAD BATTERY, NOW BUILDING AT GREEN POINT, LONG ISLAND.

Winds built to gale force. Water gained on *Monitor*, making it difficult to "keep up full steam," according to historian David Stick. The towline was ordered cut. *Monitor* sustained two leaks, and water poured in, drowning out the pumps. *Rhode Island* launched several boats and rescued some of *Monitor*'s crew, but there were still people trapped inside the ship. (Courtesy of US Naval Historical Center.)

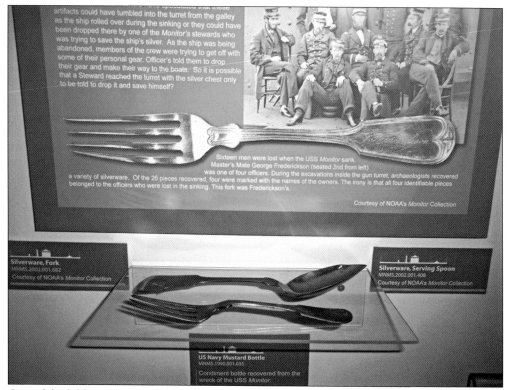

One of the lifeboats returned to the ship for the remaining crew, but it disappeared, and no trace of *Monitor* could be found. *Rhode Island* rescued 49 of the crew. The ship was discovered in 1973 and is protected under the National Marine Sanctuaries Act as the Monitor National Marine Sanctuary. Human remains from *Monitor* were brought up from the ship and interred in 2013 at Arlington National Cemetery. Pictured here is cutlery from *Monitor*. (Courtesy of Graveyard of the Atlantic Museum.)

WRECK REPORT.

Pea Island Life-Saving Station, _Seventh_ District.

Date of Disaster:

Dec 11th, 1894

1. Name of vessel.	1.	_Montana_
2. Rig and tonnage.	_336,_ 2.	_3 masted Schooner_
3. Hailing port and nationality.	3.	_Somers Point N.J. American_
4. Age.	4.	_14 years_
5. Official number.	5.	_92140,_
6. Name of master.	6.	_J. Booye_
7. Names of owners.	7.	_J. Booye & others_
8. Where from.	8.	_New York_
9. Where bound.	9.	_Charleston S.C._
10. Number of crew, including captain.	10.	_Seven_
11. Number of passengers.	11.	_None_
12. Nature of cargo.	12.	_Salt_
13. Estimated value of vessel.	13.	_$25000,_
14. Estimated value of cargo.	14.	_Dont Know_
15. Exact spot where wrecked.	15.	_1/4 mile N. of Station_
16. Direction and distance from station.	16.	_N. E. 1/4 Mile_
17. Supposed cause of wreck (specifying particularly).	17.	_By striking some unknown Obstruction_
18. Nature of disaster, whether stranded, sunk, collided, etc.	18.	_Sunk_
19. Distance of vessel from shore at time of accident.	19.	_Three miles_
20. Time of day or night.	20.	_Midnight_
21. State of wind and weather.	21.	_N. N. W. gale Snow storing_
22. State of tide and sea.	22.	_Eb tide Rough Surf_
23. Time of discovery of wreck.	23.	_11 Oclock & 45 minutes_
24. By whom discovered.	24.	_Aaron O'Neal_
25. Time of arrival of station-crew at wreck.	25.	_12,10 A.M._
26. Time of return of station-crew from wreck.	26.	_2, 45 P.M._
27. Were any of the station-crew absent? If so, who?	27.	_None_
28. Was life-boat used?*	28.	_No_
29. Number of trips with life-boat.	29.	_None_
30. Number of persons brought ashore in life-boat.	30.	_None_
31. Was surf-boat used?*	31.	_No_
32. Number of trips with surf-boat.	32.	_None_
33. Number of persons brought ashore with surf-boat.	33.	_None_
34. Was small boat used?	34.	_No_
35. Number of trips with small boat.	35.	_None_
36. Number of persons brought ashore with small-boat.	36.	_None_

* Specify model or make of boat.

Montana was a 14-year-old three-masted schooner on her way from New York to Charleston, South Carolina, when she ran into trouble near the Pea Island Life-Saving Station. The wreck report, filled out by Pea Island keeper L.S. Wescott on December 26, 1904, attributes the wreck to "striking some unknown obstruction." There was a north/northwest wind blowing a gale mixed with snow. The surf was rough. Wescott notes: "The Schooner being sunk & no lights to be seen in the thick darkness had to make a bon fire to see the wreck." They fired a line to the ship but saw no signs of life. The crew was in the fore rigging as the schooner was underwater. "We landed the first man being near exhausted it took sometime to get him in the breeches buoy." Six more men were rescued. One man died. New Inlet and Oregon Inlet Life-Saving Stations assisted. The ship was stripped, and wreckage and ship sold for $106.18. Members of the crew were sheltered at the station, with 228 meals provided. (Courtesy of Outer Banks History Center.)

On December 26, 1936, traveling from Travancore, India, to Wilmington, Delaware, *Mount Dirfys* ran aground on Frying Pan Shoals. The Greek freighter had 36 people on board and was carrying a cargo of iron ore. It took seven hours before the US Coast Guard cutter *Modoc* met up with *Mount Dirfys*. The cutter hooked up to the stranded vessel as the ship was taking on water. Due to the poor condition of *Mount Dirfys* and the possibility of her sinking, it was requested that *Modoc* pull her into port. But the freighter did not budge, and salvage operations were abandoned. The crew was landed at the quarantine station in Southport. Pictured here is tableware from the ship. (Courtesy of North Carolina Maritime Museum at Southport.)

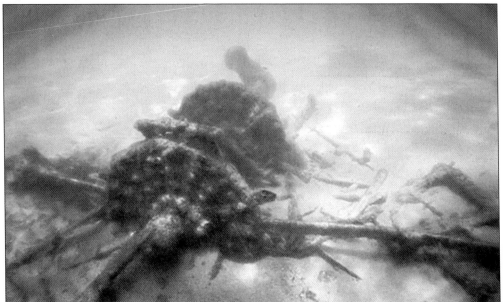

Mountaineer was a paddle wheel steamer that wrecked on December 25, 1852. The December 29, 1852, issue of the *New York Times* reports the ship was traveling from Liverpool to New York when she wrecked eight miles south of Currituck Inlet. The article calls her a total wreck but cites that the crew was saved. Diver and shipwreck researcher Marc Corbett has been instrumental in discerning the identity of this wreck, calling his findings nearly 100 percent accurate. The wreck has two very rare early side-lever steam engines that he notes are "of great historical value." Shown here is the ship's paddle wheel. (Courtesy of Jim Bunch.)

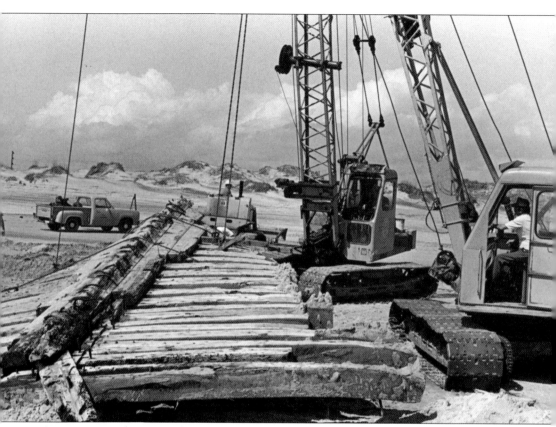

Sometimes wrecks are misidentified, remain anonymous, or are given names for where they came ashore or now sit. The latter is the case with the Nags Head Wreck, once misidentified as the *Frances E. Waters*, a schooner that capsized in 1889. Underwater archaeologist Nathan Richards, from East Carolina University and UNC Coastal Studies Institute, states, "The reconstructed lines from the Nags Head wreck indicate it exceeds the size of the historical *Francis E. Waters* by far." Richards explains that this difference actually was noted in the 1970s, but a reporter picked up the *Frances E. Waters* identification, and it stuck. The Kill Devil Hills Life-Saving Service initially discovered the wreck on the beach, where it remained until the late 1970s before being picked up by the sea and floated south. It crashed into Jennette's Pier, severing it in two, before floating south to Oregon Inlet. It took 10 hours for two state agencies to relocate the wreck to its current position in front of the Town of Nags Head municipal building. (Courtesy of Outer Banks History Center.)

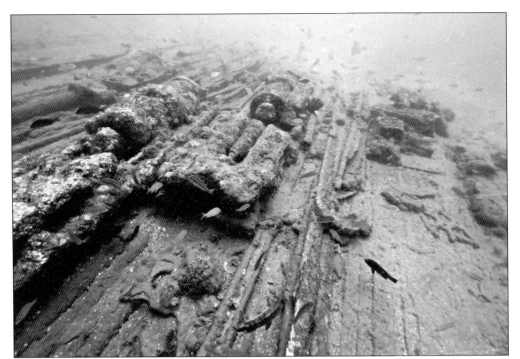

Nevada hauled materials for the federal government in support of the Union forces fighting in the Civil War. Following the war, she made regular runs between New York and Savannah carrying general cargo. The New York and Mexican Mail Steamship Line acquired the ship in 1866 and operated her until she was sold to the company of Francis Alexander and Sons on April 24, 1868. Pictured here are *Nevada* cargo remains of a steam locomotive. (Courtesy of Marc Corbett.)

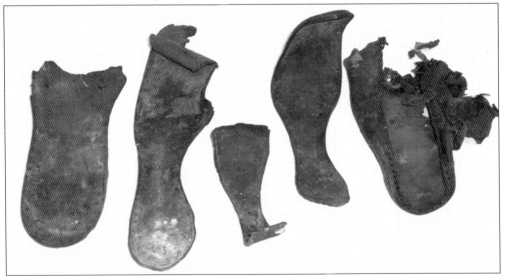

On June 3 1868, *Nevada* left New York for Vera Cruz, Mexico, via Havana, Cuba, with a load of general cargo and six passengers. Caught in thick fog off Cape Hatteras, she grounded on Diamond Shoals. The crew landed passengers on the beach via lifeboats. They tried to free the ship, but she began taking on water. Shown here are leather shoe soles from *Nevada*. (Courtesy of Graveyard of the Atlantic Museum.)

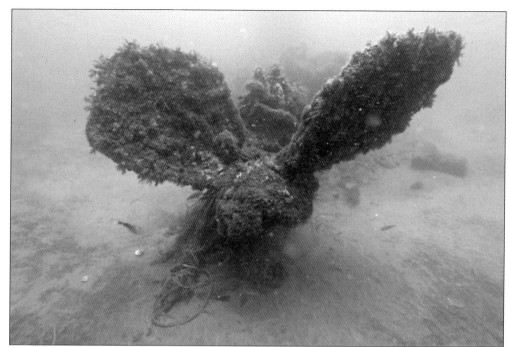

The crew of *Nevada* made for shore. The 914-ton ship sank on June 6, 1868, several miles to the southwest of Diamond Shoals in 72 feet of water. Six passengers and 19 crew survived. One crew member lost his life. A news report in the *New York Times* on June 10, 1868, cites he "was lost in an attempt to get out an anchor" and drowned. Pictured here is the ship's propeller. (Courtesy of Marc Corbett.)

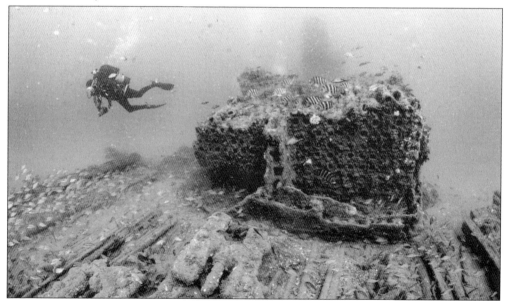

An investigation into *Nevada*'s disaster found the wreck occurred due to foul weather and strong current, but the captain was found negligent for not taking soundings. His license was revoked. *Nevada* is located about seven miles south of the Cape Hatteras Light, a few miles offshore of the town of Frisco. Shown here is *Nevada*'s boiler. (Courtesy of Hal Good.)

USS *New Jersey* was a Virginia-class battleship built between 1902 and 1906. The 435-foot vessel was sunk within a mile of Diamond Shoals Light Vessel on September 5, 1923, by Army airmen under the command of Brig. Gen. William "Billy" Mitchell (pictured). Called the father of the Air Force, Mitchell, through this exercise, proved that battleships could be sunk from the air. (Public domain.)

A makeshift airfield was created on a beach near Hatteras. USS *New Jersey* was attacked by planes about a mile above her, causing her to list "badly." It took a second attack with three bombers to sink the vessel. This effort marked the first in scrapping American war craft under the Naval Limitations Treaty. The caption about USS *Virginia* (page 125) documents the sinking of USS *New Jersey*'s sister ship in the same effort. (Courtesy of Naval History and Heritage Command.)

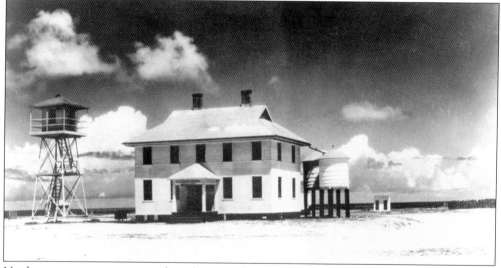

Northeastern was a youngster when she came face-to-face with an adversary capable of tearing her asunder. Built in 1901 by the Chicago Shipbuilding Company of Chicago, Illinois, the cargo carrier was transporting a load of oil from Port Arthur, Texas, to Philadelphia when she ran into bad weather. A gale and heavy fog thwarted her efforts to stay on course, and she was blown onto Outer Diamond Shoals, where she sat while wind and waves beat her mercilessly. There were 22 crew members aboard the three-year-old vessel, and seeing their peril, they shot off signal rockets through the night. Their distress signals were sighted by local lifesaving crews, and Cape Hatteras and Creeds Hill Life-Saving Stations came to their aid. The surfmen had to wait a day for the weather to calm down enough to reach the ship, where they found the crew huddled on the stern, the only section of the ship above water. It took two surfboats to get the survivors ashore safely. Shown here is Creeds Hill Life-Saving Station. (Courtesy of Graveyard of the Atlantic Museum.)

Three

O.B. Jennings to Zoave

It was August 1918 and U-boats were skulking the coast looking for shipping vessels to destroy. Tanker *O.B. Jennings*, hailing from New York, was returning in ballast from Plymouth, England, to Newport News, Virginia, with 50 crew on board. The 10,000-ton Standard Oil vessel was traveling 60 miles southeast of Cape Henry when she was caught in the sites of Fregattenkapitän Waldemar Kophamel of *U-140*. While *O.B. Jennings* carried a full gun crew, the tanker was no match for the German submarine, which could outrun the American ship at 26 knots to her 10. But the tanker did a good job performing a zigzag course and dropping smoke boxes overboard to mask its presence. The U-boat fired more than 40 shots before hitting the vessel. (Courtesy of Outer Banks History Center.)

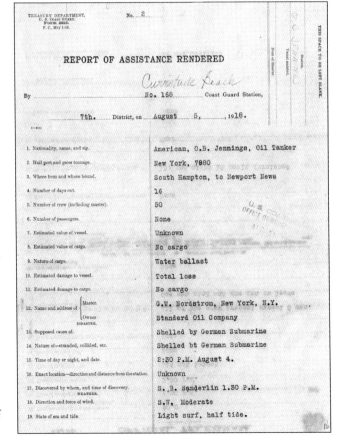

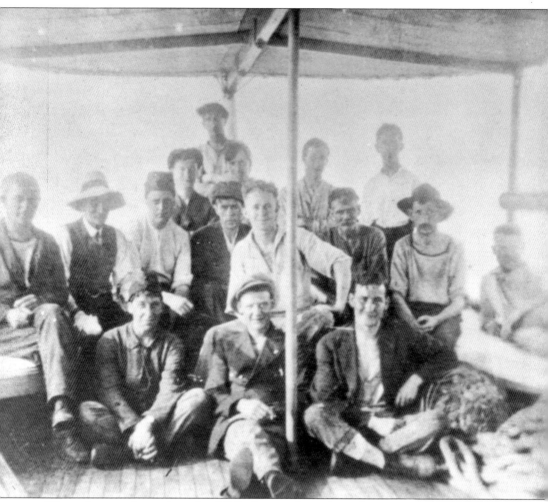

Those shots made quick work of *O.B. Jennings* by striking the engine room and the tanker's magazine. Capt. George Nordstrom ordered the crew to abandon ship, and the lifeboats were lowered. Second steward James H. Scott was killed in the explosion, and Captain Nordstrom exchanged clothing with him as a disguise. It was in his favor to do so for the U-boat came alongside the lifeboats and inquired after the captain. They were told he had died in the explosion. The Germans took a prisoner instead—Second Officer Rene Bastin. That evening, occupants of two of the lifeboats were rescued by the destroyer USS *Hull*. The following morning, the Italian steamer *Umbria* located and rescued the crew, including the captain, from the third lifeboat. Shown here is the crew of *O.B. Jennings*. (Courtesy of Graveyard of the Atlantic Museum.)

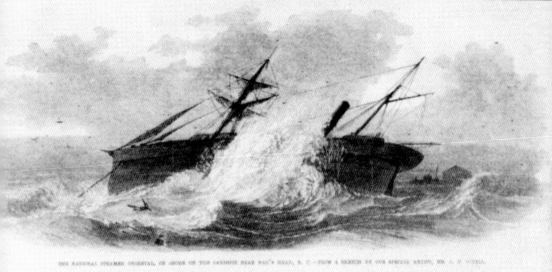

THE NATIONAL STEAMER ORIENTAL, OR ASHORE ON THE SANDSPIT NEAR NAG'S HEAD, N. C.—FROM A SKETCH BY OUR SPECIAL ARTIST, MR. A. R. WAUD.

THE U. S. TRANSPORT ORIENTAL WRECKED BODY'S ISLAND, N. C.

On May 16, 1862, US transport steamer *Oriental* was lost in fog and grounded off Bodie Island. A period newspaper reported that Brig. Gen. Rufus B. Saxton was on board the Civil War vessel as it sailed for Port Royal, South Carolina, before being wrecked that evening. All were saved, but a portion of the cargo was lost; the remainder was saved on the beach. What is remarkable about this event and reported in the same newspaper article is that J.A. Fuller of New York "went 65 miles in a storm in a canoe, across the sound, to Fort Hatteras, for assistance, which, by his energy, was obtained." Col. Rush Hawkins, commander at Roanoke Island, traveled south to take possession of the property and place a guard over it. The passengers were picked up by the steamer *George Peabody*. (Courtesy of National Park Service, Cape Hatteras.)

On Thursday, March 6, 1980, Old House Channel became the gathering place for grounded trawlers. It had been three years since the channel had been dredged, and it became unnavigable following gale-force winds. Trawlers *Osprey* and *Tarheel*, shown here, grounded along with three other fishing vessels. *Osprey* eventually was refloated and pulled free by two trawlers. The incidents were apparently enough to have officials waive permits to allow the dredge *Schweitzer* to quickly begin deepening the channel. (Courtesy of Outer Banks History Center.)

On May 4, 1943, *Panam* was running in convoy NK-538 from Norfolk to Lake Charles, Louisiana. The 7,277-ton tanker was straggling due to engine troubles. *Panam* was caught in the sites of *U-129* and hit by a torpedo on the port side of the engine room. Two men were killed. Another torpedo struck on the port side amidships. The 49 survivors took to three lifeboats and were picked up by USS *SC-664*. The ship sank off Cape Lookout. (Courtesy of Gary Gentile.)

Papoose worked for 15 years as a trade boat before her final trip. On March 18, 1942, she was steaming along from Rhode Island to Texas, her mission to pick up a load of crude oil. She was following Navy recommendations to travel close to the coast, as merchant shipping was falling prey to German submarines. *Papoose* was running in a blacked-out state and was passing Diamond Shoals when she was struck by a torpedo. A combination of oil and water caused massive flooding, and Capt. Raymond Zalnick ordered abandon ship. But it was not yet over for *Papoose* as the Germans launched a second torpedo that nearly hit one of the lifeboats and tore into the hull of *Papoose*. The ship eventually capsized. Two men were lost, and 34 crewmen, stowed in two lifeboats, were picked up by the US destroyer *Stringham*. The perpetrator, *U-124*, was lost less than a month later west of Gibraltar. (Courtesy of Gary Gentile.)

Great mystery surrounds the disappearance of the schooner *Patriot*. At the heart of it is a portrait said to have been found aboard a vessel that washed ashore at Nags Head either at the end of 1812 or beginning of 1813. Some believe the 12-by-18-inch portrait is that of Theodosia Burr Alston, the wife of South Carolina governor John Alston and daughter of former vice president Aaron Burr. She was on board *Patriot* as it traveled from South Carolina to New York, where she was going to visit her father. But the former pilot boat never reached its destination. It is known that a fierce storm was blowing off Cape Hatteras when *Patriot* was due in that area. But whether the ship wrecked or was the victim of war or piracy has never been discovered. Stories surrounding Alston's disappearance include a deathbed confession by a man relating the capture of the vessel and subsequent murder of all on board. The portrait (pictured here) was viewed by descendants of Alston and credited as having a great likeness to the governor's wife. (Public domain.)

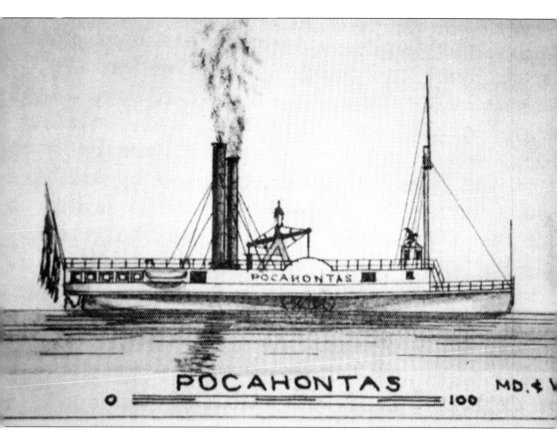

On January 18, 1862, three days after the sinking of steamer *Zoave*, which was part of the Burnside Expedition to overtake Roanoke Island during the Civil War, nearly 90 horses on board the Union wooden paddle wheel steamer *Pocahontas* were drowned when the ship went ashore during a storm. The horses belonged to the Rhode Island Battery, with several valued at $500 each. While it is still being debated, a ship that some divers believe is *Pocahontas* can be seen today off Salvo. The wreck site features steam engine parts, the shaft, and one of the hulls of a paddle wheeler, according to local diver Marc Corbett. The wreck is in 10 to 15 feet of water about 75 yards from the shore and can be located by looking for the paddle wheel shaft sticking out of the water. (Public domain.)

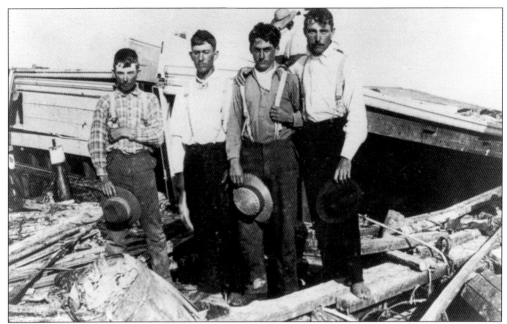

Barkentine *Priscilla* and her crew fell prey to the San Ciriaco hurricane of 1899. Caught in pounding seas, her captain and his family met with losses before surfman Erasmus Midgett heard their cry for help. By the time Midgett arrived by pony at the wreck site, the captain's son already had been torn from his arms to drown. His wife and elder son, the ship's mate, were washed overboard. Shown here are survivors from *Priscilla*. (Courtesy of Outer Banks History Center.)

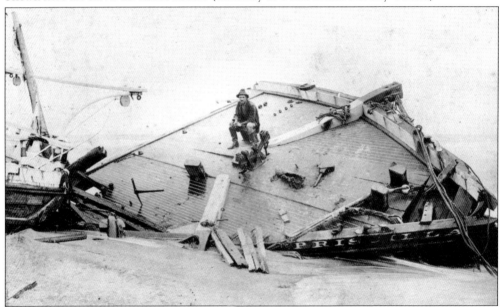

Erasmus Midgett (pictured) realized he had no time to ride for help as *Priscilla* was already breaking apart. He waited for each wave to ebb before moving through hurricane swells toward the ship. This was done seven times until all ambulatory crew were brought to safety. Three men remained on board too wounded to walk. Midgett climbed aboard the collapsing vessel and carried the remaining survivors to shore. (Courtesy of National Park Service, Cape Hatteras.)

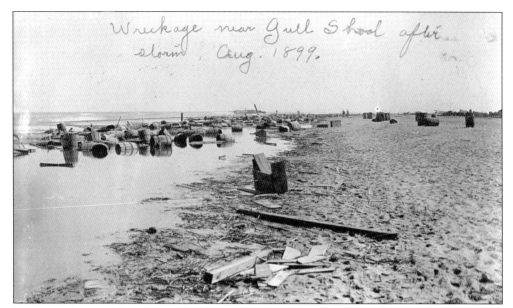

Wreckage near Gull Shoal after storm, Aug. 1899.

Seventeen ships met their fates in the Graveyard of the Atlantic during San Ciriaco. The hurricane wreaked havoc on the Outer Banks, drowning cattle, flooding homes, and causing residents to flee to high ground. Wreckage, seen here, washed ashore on the Outer Banks from the hapless vessels caught in the Category 4 storm's wrath. (Courtesy of Outer Banks History Center.)

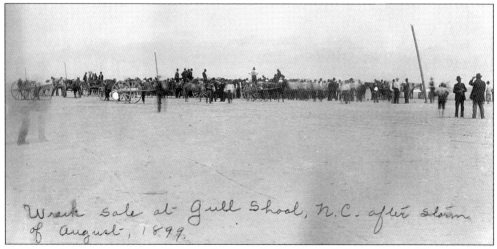

Wreck sale at Gull Shoal, N.C. after storm of August, 1899.

While tragic in nature, shipwrecks were also a way for locals to gain items not readily available on the isolated Outer Banks. Official auctions were held to fairly divide the goods and profits. Items that made their way into the hands of islanders included fruit, shoes, lumber, and dinnerware. This photograph shows islanders meeting for an auction. (Courtesy of Outer Banks History Center.)

110F NOUVELLE·CALEDONIE Rade de Balade 185:

Le Phoque
Le Prony
Le Catinat

ITVF LAVER

Multiple mishaps surround the wreck of the French corvette *Prony*. During a gale on November 5, 1861, the man-of-war grounded on a shoal off Ocracoke. A pilot believed the ship could be refloated at high tide. He left for help. Hours passed. The captain sent a boat ashore to investigate, but a strong surf prevented all from returning to the ship. The crew lightened and tried to refloat the vessel. Four ships bearing the US flag approached the corvette, and the *Prony* crew communicated their need but were repeatedly told it would only be possible to assist come high tide. The ships left and never returned. In the meantime, the Confederate privateer *Winslow* was on the way to assist *Prony* and struck a sunken vessel. Eventually, the 140 crew members of *Prony* were rescued and placed on board the Confederate steamers *Seabird* and *Ellis*. They ran aground near the Lock of the Albemarle and Chesapeake Canal and were aided by the steamer *J.B. White*. *Prony* was burned to prevent it from falling into Federal hands. (Courtesy of Philatelie Marine.)

Proteus was a passenger-freighter built in 1900 by Newport News Ship Building & Dry Dock Company of Newport News, Virginia. She was making her way from New Orleans when she ran into trouble off Ocracoke Island. Despite being in the infamous Graveyard of the Atlantic, where weather could put a ship in harm's way, the August 19, 1918, evening was calm. Due to being in the vicinity where U-boats patrolled, *Proteus* was running without her navigational lights. The 4,836-ton vessel ran into the Standard Oil tanker *Cushing*, also in a blacked-out state, and sustained a hole in her starboard side. The ship was abandoned. One man panicked and was said to have jumped overboard and drowned. The survivors were picked up by *Cushing. Proteus* sank with damages estimated at $70,000. Shown here is a window from *Proteus*. (Courtesy of Graveyard of the Atlantic Museum.)

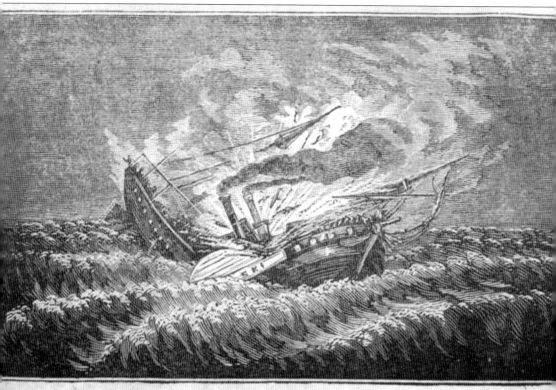

Explosion of the Steam Packet Pulaski.

In mid-June 1838, steam packet *Pulaski* left Charleston, South Carolina, with about 150 people aboard headed for a trip up the coast. While most passengers were sleeping, a boiler blew up, sending sprays of deadly steam about the aft cabin, which became strewn with lifeless bodies. The boat was blown to pieces and took on water. People were holding on for dear life, floating on debris and watching as fellow passengers—men, women, and children—drowned. The survivors took to deck boats and makeshift rafts attempting to make it to shore. One boat was flipped by a strong breaker. Many tried to swim to land. One such passenger felt something bump against his leg and dove down to discover a woman with an infant strapped to her and saved them. Crew from *Henry Camerdon* rescued many survivors. Groups on rafts or boats made it to land, including a man and women who cast adrift together—after he saved her from the sea—were said to fall in love and marry. (Courtesy of S.A. Howland.)

Called Ramp 55 Wreck, these remains are seen periodically on a Hatteras Village beach. The wreck was the focus of a Student Archaeology Workshop in 2006. They discovered part of a bowsprit or support for one, which would indicate a sailing vessel. The vessel was built using both wooden treenails and iron bolts. This possibly indicates it was constructed sometime between the Civil War and the turn of the 20th century. (Author's collection.)

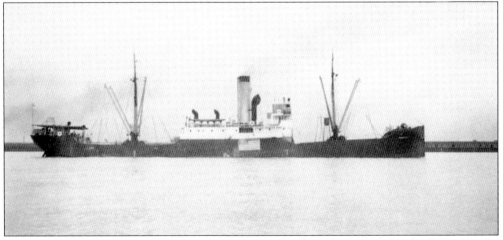

Raritan was a 2,649-ton freighter that traveled far and wide picking up and unloading cargo. In late February 1942, she was carrying a boatload of coffee headed from Buenaventura, Colombia, to New York. *Raritan* encountered a storm off the North Carolina coast that grounded her on Frying Pan Shoals. A distress call was sent out, and a motor lifeboat was sent to the rescue. All 29 crewmen were saved. (Courtesy of Gary Gentile.)

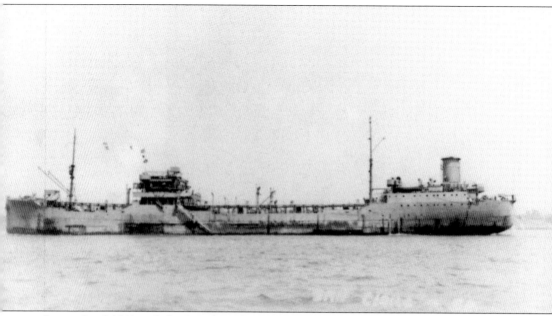

It was April 1942 and the British tanker *San Delfino* was traveling through dangerous waters. The 8,072-ton vessel was armed and moving in a blacked-out state about 10 miles east of Wimble Shoal Buoy when she was attacked by *U-203*, under the command of Kapitänleutnant Mutzelberg. Sources vary on just how many and which torpedoes took the ship down. But it is clear that she was carrying 11,000 tons of aviation gas and burst into flames. A torpedo is believed to have ignited the ammunition she was also carrying. Abandon ship was called for but doing so was a catastrophe all its own. One lifeboat carrying 28 crewmen caught fire, and all perished. The 21 occupants of a second lifeboat were rescued, but again sources differ on the rescue vessel. One names the fishing trawler *Two Sisters*, and another recognizes HMS *Norwich City* as the rescue vessel. A third lifeboat was sighted but found empty. Pictured here is *San Delfino*'s sister ship *San Cirilo*. (Courtesy of Shaw Collection, Steamship Historical Society Archives.)

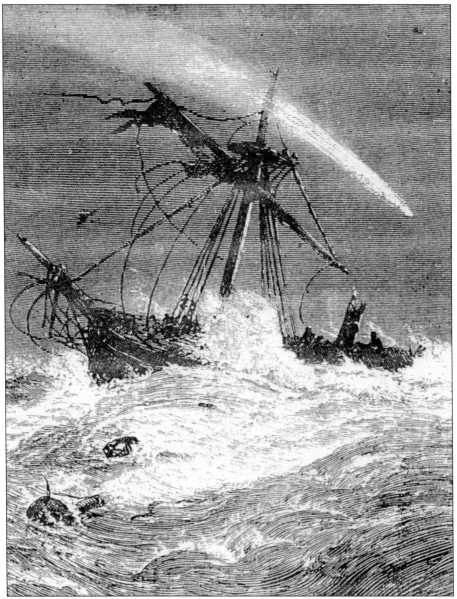

On February 9, 1905, keeper William H. Gaskill of the Cape Lookout Life-Saving Station spotted a ship's mast. He and his crew of eight men took the surfboat to the scene. They rowed for four hours to reach the wreck grounded on the shoals. *Sarah D. J. Rawson*'s rigging, main topmast, deckhouses, bowsprit, and foremast were gone. One man washed overboard. Rough breakers surrounded the wreck, making it impossible to get near the ship. The crew attempted to reach her until nightfall then anchored at sea. Come light, they repeated their attempts until a shift in the wind and tide change allowed the surfboat to gain ground. A line was tossed to the vessel. A sailor secured himself to it and was pulled to safety, and everyone was saved. The lifesavers took off their oilskins and wrapped the sailors in them before rowing nine miles to shore. The schooner, hailing from Camden, Maine, "went to pieces soon after the rescue," writes David Stick in *Graveyard of the Atlantic*. The rescuers were awarded gold medals of honor. (Courtesy of Sonny Williamson.)

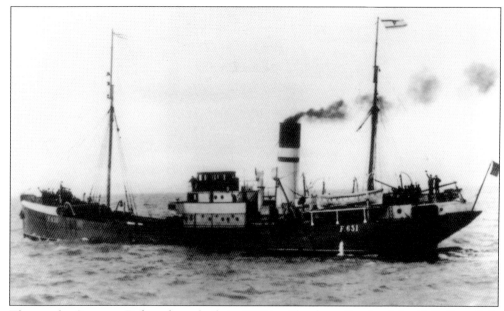

The trawler *Senateur Duhamel* was built in 1927 in Aberdeen, Scotland, by Hall, Russell & Company, Ltd. On loan from the Royal Navy, the armed vessel was sent over from Britain during World War II to protect convoys from U-boats. On May 6, 1942, the steam-propelled fishing vessel was heading toward Beaufort Inlet, North Carolina, when she spotted USS *Semmes*. The trawler flashed the message, "what ship?" The crew of the receiving ship was said to be blinded by the light, and the bow of USS *Semmes* subsequently rammed into the trawler amidships. *Senateur Duhamel* called the destroyer USS *Roper* for help. Meanwhile, it was discovered that a man, J. Woods, from *Senateur Duhamel*, had climbed aboard USS *Semmes* when the two ships had been connected. (Courtesy of Shaw Collection, Steamship Historical Society Archives.)

An executive officer and J. Woods took a boat from USS *Semmes* and set out to search for *Senateur Duhamel*. They arrived just as *Senateur Duhamel* was sinking below the water. The masts marked the location, and Woods and the officer were able to locate all the crew and took them to USS *Roper*. There were no fatalities. In 1944, the trawler was dynamited and wire-dragged as a navigational hazard. Pictured here is an oil lamp credited by the Graveyard of the Atlantic Museum to be from *Senateur Duhamel*. (Courtesy of Graveyard of the Atlantic Museum.)

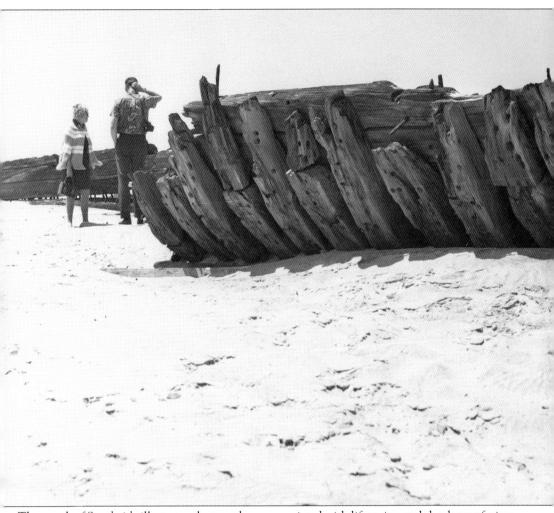

The wreck of *Strathairly* illustrates the true drama associated with lifesaving and the danger facing all sailors traveling through the Graveyard of the Atlantic. On March 24, 1891, the schooner-rigged screw steamer from Newcastle, England, met with dense fog north of Hatteras before stranding in the wee hours of the morning. With 26 men on board, she signaled for help, her steam whistle piercing the thick night air. Steamer *Strathairly*'s call for help was answered by a red Coston flare fired by a surfman from the Chicamacomico Life-Saving Station. The lifesaver left the scene to return to the station for help. The Chicamacomico crew arrived at the wreck site an hour later. The fog was such that it was impossible to see the vessel. The crew tried to reach her, shooting a line in her direction, but fell short. The seas were so rough, the surfmen were unable to reach the ship in a lifeboat. (Courtesy of National Park Service, Cape Hatteras.)

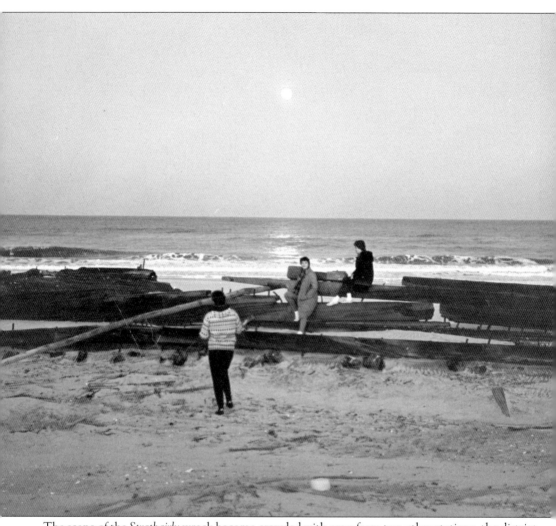

The scene of the *Strathairly* wreck became crowded with crew from two other stations, the district superintendent of the US Life-Saving Service, and townsfolk from Chicamacomico. The crowd at the wreck witnessed attempt after attempt by the lifesavers to reach the ship. Over the rough surf, they could hear the voices of the stranded men and the occasional sound of the ship's whistle. When the fog finally lifted, they saw that the vessel was broken in two, and 23 of the 26 crewmen were crowded onto the bow. Three of the crew—the captain, chief engineer, and first mate—had already drowned. The lifesavers continued firing shots. Some fell short, or the rope broke off. Exhausted and injured men were dying on board. The remaining crew jumped into the sea wearing lifebelts. They were dragged to shore, but only seven men survived the ordeal. (Courtesy of National Park Service, Cape Hatteras.)

The freighter *Suloide* was a German vessel built in 1920. The transport freighter was loaded with manganese when she met her fate off Bogue Banks. On March 26, 1943, the ship collided with the submerged *W.E. Hutton*, which had been sunk by U-boats a year earlier. Pictured are a door handle and plate credited by the Graveyard of the Atlantic Museum to be from *Suloide*. (Courtesy of Graveyard of the Atlantic Museum.)

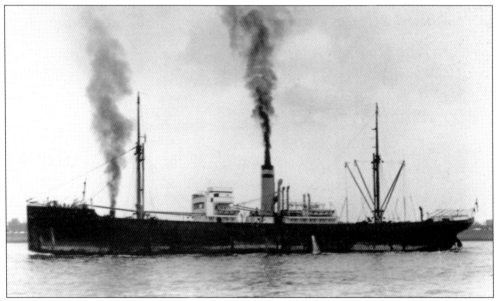

Suloide sustained a gash and began to take on water. The tug *P.F. Martin* attempted to rescue *Suloide*, but she broke free and sank. A little less than a year later, Coast Guard cutter *Vigilant* blasted it to avoid having the upright ship become a navigational hazard. *Suloide* also was wire-dragged to remove any high spots. Pictured here is the future *Suloide* as *Amassia*. (Courtesy of Uhle Collection, Steamship Historical Society Archives.)

Tamaulipas was traveling with a load of oil on her way from Tampico, Mexico, to New York. It was April 9, 1942, when she was in the vicinity of Cape Lookout, an area known to be infested with German submarines. A torpedo was spotted crossing the wake of the ship. Capt. Allan Falkenburg had the ship go into zigzag mode in an effort to keep from becoming a spoil of war. But his efforts were in vain, for a blast from *U-552* hit the starboard side of the ship. The ship broke in two. Several men jumped overboard, with two additional crew killed in the blast. Two lifeboats filled with 35 survivors were picked up by HMS *Norwich City* and taken to Morehead City. Shown here is a handwheel believed to be from *Tamaulipas*. (Courtesy of Graveyard of the Atlantic Museum.)

The history of USS *Tarpon* includes seven battle stars for her World War II service before her inglorious ending. The 298-foot submarine weighed 1,500 surface tons and was built by Electric Boat in Groton, Connecticut. Her hull was launched on September 4, 1935. USS *Tarpon* operated out of San Diego and Pearl Harbor before traveling to Manila to increase the Pacific force. (Courtesy of US Naval Historic Command.)

USS *Tarpon*'s history includes being hit by four depth chargers and running aground while navigating Boling Strait. Subsequent patrols found her sinking a cargo ship, a transport loaded with soldiers, and bombing a radio station. She headed for Japanese waters and fired a spread of torpedoes at two escorted cargo ships, damaging another freighter and sinking a patrol ship and its crew. Pictured here is USS *Tarpon*'s rudder angle indicator. (Courtesy of Graveyard of the Atlantic Museum.)

On USS *Tarpon's* ninth patrol off the coast of Honshu, she tracked a large ship and sent out four torpedoes, which stopped the vessel. The enemy ship got under way again and was headed for USS *Tarpon* when the American submarine submerged and went under the ship to attack from the other side. USS *Tarpon* fired four torpedoes and sank the ship. Shown here is part of USS *Tarpon's* deck lamp. (Courtesy of Graveyard of the Atlantic Museum.)

USS *Tarpon* was ordered to the East Coast of the United States. She eventually was decommissioned and scheduled for duty as a Naval Reserve training ship before leaving service and being struck from the Navy list on September 5, 1956. In August the following year, she was on the way to the scrapyard when she foundered in deep water southeast of Cape Hatteras and sank. Pictured here is USS *Tarpon's* conning tower alarm bell. (Courtesy of Graveyard of the Atlantic Museum.)

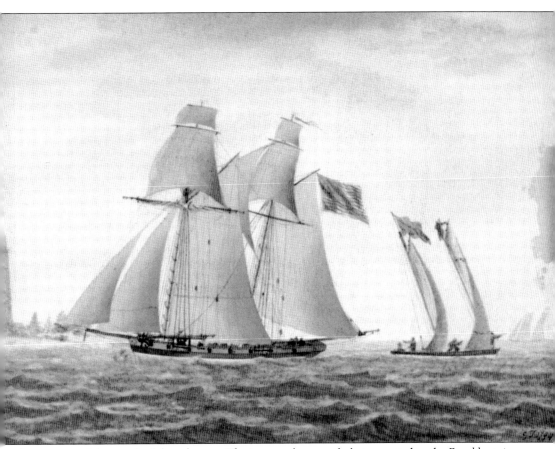

An account of the wreck of the schooner *Thetis* comes by way of a letter posted in the *Poughkeepsie Journal* on January 29, 1812. Under the command of Capt. William Pike, the ship left New York with 10 passengers on board. They "experienced six violent gales" and were out of firewood and provisions and nearly out of water. They tossed about for 23 days. On December 24, they grounded on Cape Hatteras shoals. Seas of "ten or fifteen feet" broke over the vessel that quickly broke into pieces. The mate drowned after jumping into the sea in hopes of reaching shore to seek help. Lifesavers rescued the men but thought the women on board lost. "At this moment the stern of the wreck swung around to the shore . . . a negro man rushed to the beach and resolutely declared he would have their bodies or lose his own." He climbed aboard and discovered the women on a narrow berth just above the water. He "dropped them all out to those who ventured into the surf to receive them almost in a state of insensibility." (Courtesy of the National Maritime Museum, Greenwich, London, England.)

Crew from the Greek freighter *Tolmidis* radioed for help at 6:30 a.m. on January 18, 1978. Located 85 miles south/southeast of Oregon Inlet, the vessel was taking on water and in danger of sinking. It was reported that there was 17 feet of water in the engine room, and all power was lost. US Coast Guard air and sea rescue crews and an Atlantic Coast Pollution Strike Team responded. The Coast Guard delivers equipment to the ship in the photograph at left. (Courtesy of Outer Banks History Center.)

The US Coast Guard shipped to *Tolmidis* a pump capable of pumping 1,500 gallons a minute and airlifted most of the crew. The survivors were greeted with Outer Banks hospitality, being housed at a local inn and treated to a covered dish dinner compliments of the Outer Banks Women's Club. Interpreters were provided at the dinner, where the ship's chief officer said, "Seamen everywhere are aware of the dangers of the Atlantic off Cape Hatteras." Shown here are 10 members of the 30-man crew. (Courtesy of Outer Banks History Center.)

Tolmidis's sailors were encouraged to entertain the group with traditional Greek dances. A thank-you appears in the January 26 edition of the *Coastland Times*: "The crew of the Greek ship thank with all their hearts the Coast Guard and everyone else who showed concern for them, visited and entertained them." *Tolmidis* was brought to Hampton Roads, Virginia, for repair. Heavy-duty dewatering equipment (pictured) was flown to the ship. (Courtesy of Outer Banks History Center.)

In April 1942, U-boats were wreaking havoc on shipping off the Outer Banks. In a three-month period, they sank 50 large ships with no losses themselves. The tide was about to change come April 14 when *Jesse Roper* dodged a torpedo just south of Wimble Shoals. She opened fire with her deck guns and did great damage to *U-85* while it was attempting to submerge. *Jesse Roper* used her depth charges to finish off the vessel (seen here). (Courtesy of Jim Bunch.)

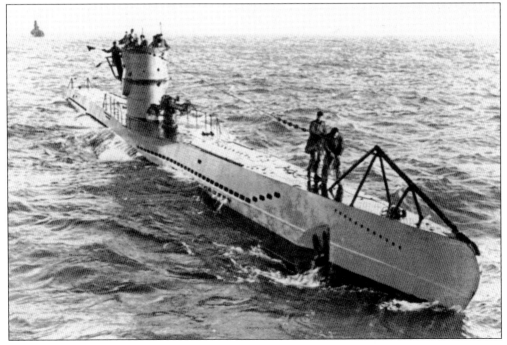

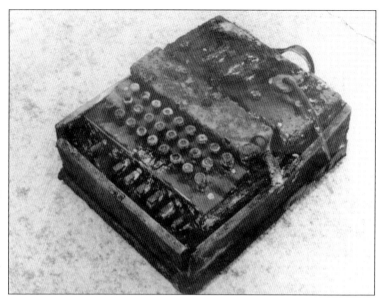

While bodies were recovered from the destruction of *U-85*, a plane circling *Jesse Roper* kept watch from above. Twenty-nine bodies were picked up and later interred at Hampton National Cemetery in Virginia. The destruction of *U-85* marked the first U-boat sinking off the coast during the war. Pictured here is an Enigma machine from *U-85*. (Courtesy of Jim Bunch.)

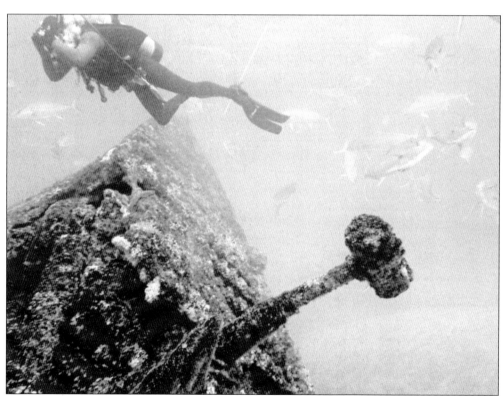

In July 1942, following the wreck of *U-701*, Kptlt. Horst Degen and part of his crew were lost for 49 hours in a summer sea. One by one, crewmen from two groups of survivors succumbed to heat, exhaustion, and dehydration. Clinging to life preservers and flotsam from the wreck, they attempted to keep one another alive through supportive words and also held the kapitänleutnant's head up to keep him from drowning. Shown here is *U-701*'s bow. (Courtesy of Marc Corbett.)

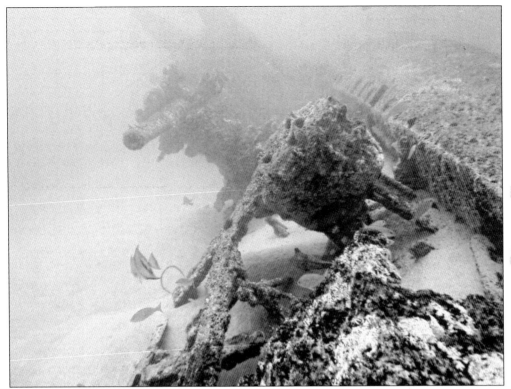

The wreck of *U-701* was caused by aerial depth charges and came only after the submarine had successfully laid mines in the Chesapeake Bay area before heading to North Carolina waters. The Army A-29 bomber dropped three depth charges. Eighteen crewmen were catapulted out of the conning tower hatch; an additional 15 men escaped through the bow of the submarine. The remaining crew—43 men—went down with the ship. Pictured here is a deck gun from *U-701*. (Courtesy of Marc Corbett.)

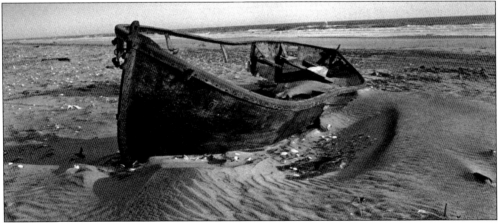

Once a ship was caught upon a shoal, it was essential for lifesavers to get the crew off the vessel as quickly as possible. It was not unusual for sailors to tie themselves into the rigging to keep from being swept to sea. Rowing a lifeboat into the storm was one way to rescue sailors from a hapless ship. Shown here is an unidentified lifeboat that was a shipwreck victim itself. (Courtesy of J. Foster Scott, Outer Banks History Center.)

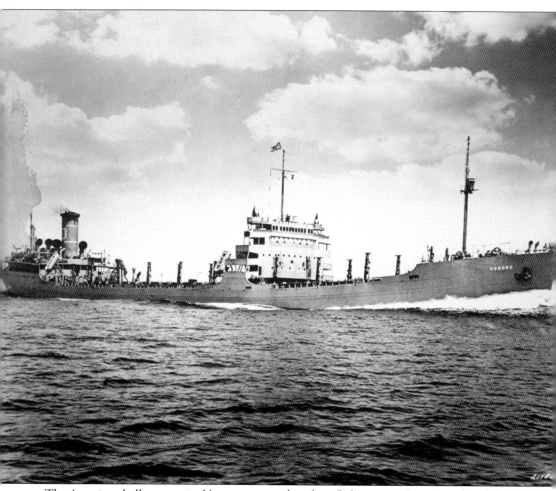

The American bulk ore carrier *Venore* was traveling from Baltimore to Cruz Grande, Chile, when she ran into trouble around Diamond Shoals. It was January 23, 1942, and U-boat activity regularly threatened shipping activity. Before being hit by a torpedo themselves, the crew of *Venore* witnessed the fiery explosion of *Empire Gem*. *Venore*'s sidelights were then diminished, and while running in darkness, the radio operator transmitted distress calls. *U-66* began to chase *Venore* and launched a torpedo at the 8,017-ton vessel. The damage did not stop the ship, but it caused enough panic for multiple crew members to take to the lifeboats, which were quickly lost. One man jumped into the sea and was drowned. A second attack came, and Capt. Fritz Duurloo ordered abandon ship. The men stayed in a crouched position in the lifeboat for a long period to avoid being spotted by the U-boat. They spent 38 hours drifting in the open boat before being rescued. Twenty-one lives were lost. (Courtesy of The Mariners' Museum, Newport News, Virginia.)

On May 8, 1903, the barkentine *Vera Cruz VII* was traveling from the Cape Verde Islands to New Bedford, Massachusetts, when she drug her anchor and went into the breakers. She stranded on Dry Shoal Point with 22 crew and 399 passengers on board. The 29-year-old ship was carrying 214 barrels of whale oil valued at $6,000. The Portsmouth Life-Saving Station crew brought 23 women, three children, and two men in by surfboat. (Courtesy of Outer Banks History Center.)

The following morning, the sea was getting rough. Several surfboats were used to take the remaining 371 people to Dry Shoal Point. A wreck report from the US Life-Saving Service indicates that the "shoal was covered with water before we got them all off had to be very watch full to keep them from sinking the boat." The Portsmouth community baked bread to help feed the survivors. A Monomoy surfboat, the type used in the rescue, is pictured here. (Courtesy of Graveyard of the Atlantic Museum.)

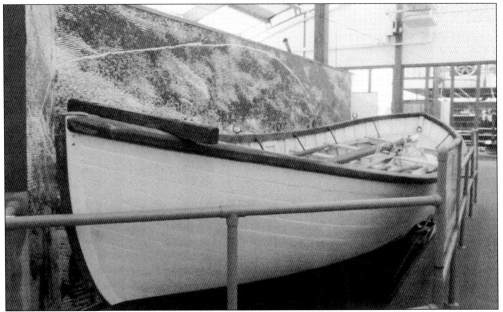

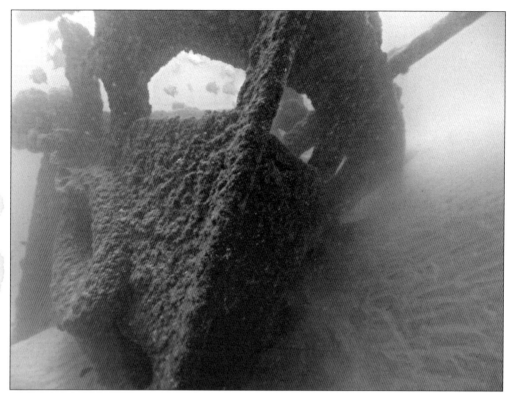

On February 20, 1918, enveloped in heavy fog, the British steamer *Veturia* ran aground on Diamond Shoals off Cape Hatteras. While her SOS was picked up by Coast Guard cutter *Onondaga*, it was at first impossible to pinpoint her location due to poor visibility. The Coast Guard attempted to send out a surfboat, but heavy seas and strong tide thwarted their attempt to reach the ship. Shown here is *Veturia*'s bow. (Courtesy of Marc Corbett.)

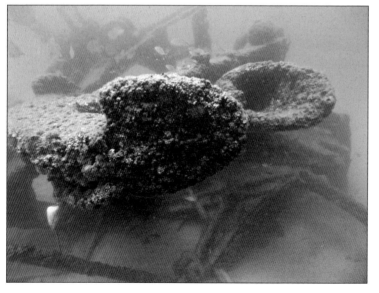

Onondaga searched for *Veturia* for half a day and finally made contact at 10:00 in the evening. They launched boats, and seven trips were made to take the 47-member crew back to *Onondaga*. This effort took four hours and included the rescue of three cats. The vessel was a total loss, including her load of nitrates. Shown here is *Veturia*'s fluke anchor. (Courtesy of Marc Corbett.)

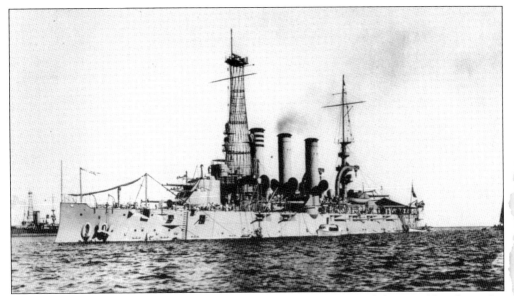

USS *Virginia* played a role in proving that battleships could be sunk by aerial bombing. On September 5, 1923, under the command of Brig. Gen. William "Billy" Mitchell, the ship was bombed from 3,000 feet within a mile of the Diamond Shoals Light Vessel. The planes took off from a temporary field on a Cape Hatteras beach. The vessel was 441 feet 3 inches long and weighed 14,948 tons. It sank 30 minutes after the experimental attack. (Courtesy of Naval History and Heritage Command.)

W.E. Hutton was sunk near Cape Lookout on March 18, 1942, by U-boat fire. The tanker was traveling unarmed and alone from Texas to Pennsylvania with 65,000 barrels of heating oil. She was in a blacked-out state. A torpedo from *U-124* hit the 7,076-ton vessel. *W.E. Hutton* was trying to make it to shore when she was struck again. The impact caused a fiery explosion. The 23 survivors were picked up by MS *Port Halifax*. Thirteen crew members were killed. (Courtesy of Gary Gentile.)

LOSS OF THE OLER.

The tug Underwriter, Capt. Wiley, which had in tow the schooner Wesley M. Oler just before she was wrecked off Cape Hatteras in the gale last week, when all on board were lost, arrived here yesterday. The Oler, guano laden, had put into Nassau in a disabled condition. On Nov. 30 the tug left that port with the vessel.

"When off Frying Pan Lightship near Savannah," Capt. Wiley said, "we caught a heavy southwest ground swell. It continued to increase, and on Thursday it had settled down to a long, steady roll such as I have never seen in all my career of fifty years at sea.

"The schooner, until Thursday, kept most of her canvas up to steady her, and at the same time make our job as easy as possible. About noon that day the sails had to be taken in, the wind being too strong. That was the beginning of the end, for after that the wind gained so steadily in strength that, when night fell, it was blowing a gale of from fifty to sixty miles an hour, although it seemed to be a hundred.

"The wind increased in fury, and at 2:30 o'clock Friday morning the schooner, which was tugging and pulling at the hawser, gave a great lunge, and when she settled back the hawser broke, and she drifted away. I had the tug stopped and started on a hunt for the vessel. Twenty minutes later we made her out, rolling heavily in the sea, with the big roller breaking over her. I stood by until daylight, but I never saw the Oler again."

The Oler went aground off Hatteras.

The crew of the four-masted schooner *Wesley M. Oler* met with disaster when they abandoned their ship that grounded on Hatteras Inlet bar. The ship was being towed from Nassau to New York when it parted its hawser. When lifesavers arrived at the scene, the ship was in pieces with high seas thwarting any attempt to reach her. No one survived. The ship and its cargo of guano were a total loss. (Courtesy of the *New York Times*.)

On December 2, 1893, steamer *Wetherby* was on her way to Norfolk, Virginia, from Fernandina, Florida, when she grounded on Outer Diamond Shoals. The British vessel was carrying a crew of 24 and a cargo of phosphate rock valued at $50,000. Surfmen from the Cape Hatteras Life-Saving Station set out in a surfboat and found the steamer rapidly filling with water. They escorted the entire crew to safety with the help of Big Kinnakeet and Creeds Hill Life-Saving Stations. Shown here is *Newcastle City*, sister ship of *Wetherby*. (Courtesy of Steamship Historical Society Archives.)

On April 3, 1915, high tides and hurricane winds were ravaging the coast. Schooner-barge *William H. Macy* was being towed by *Edward Luckenbach* to Norfolk, Virginia, when she broke loose and was stranded east of the Wash Woods Coast Guard Station. The Pennys Hill Coast Guard Station came to the rescue aided by the Wash Woods Coast Guard Station. The crew of four was rescued using the breeches buoy. Shown here is the ship's nameboard. (Courtesy of Graveyard of the Atlantic Museum.)

A victim of weather and shoaling at Hatteras Inlet during the Civil War, the steamer *Zoave*, part of the Burnside Expedition, sank on January 14, 1862. The gunboat dragged her anchors and had a hole punched in her. While she was a total loss, her crew and guns were saved. (From *Harper's Weekly*.)

Wreck of the Zouave in Hatteras Inlet

DISCOVER THOUSANDS OF LOCAL HISTORY BOOKS
FEATURING MILLIONS OF VINTAGE IMAGES

Arcadia Publishing, the leading local history publisher in the United States, is committed to making history accessible and meaningful through publishing books that celebrate and preserve the heritage of America's people and places.

Find more books like this at

www.arcadiapublishing.com

Search for your hometown history, your old stomping grounds, and even your favorite sports team.

Consistent with our mission to preserve history on a local level, this book was printed in South Carolina on American-made paper and manufactured entirely in the United States. Products carrying the accredited Forest Stewardship Council (FSC) label are printed on 100 percent FSC-certified paper.

MADE IN THE
USA